THE COMPLETE GUIDE TO **PAINTING WATER**

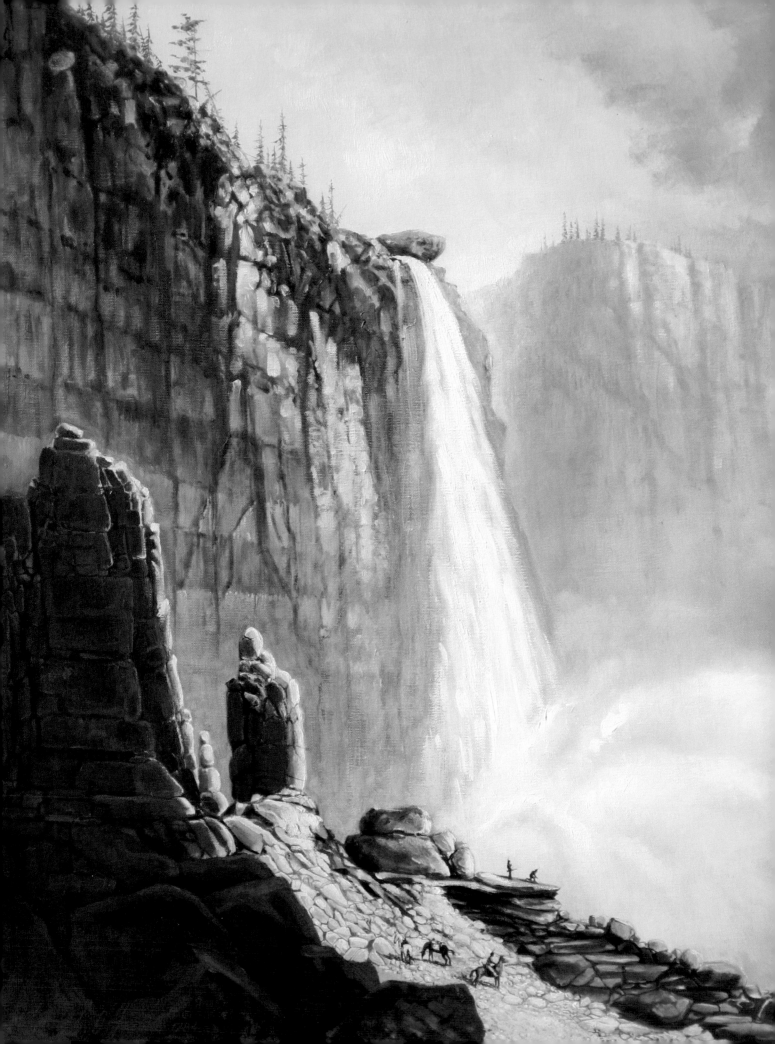

THE COMPLETE GUIDE TO PAINTING
WATER

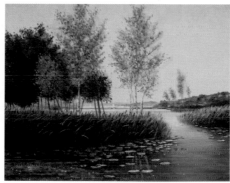
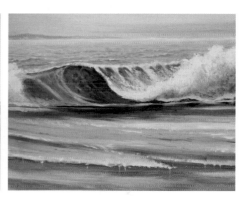

BERT N. PETRI

NORTH LIGHT BOOKS
CINCINNATI, OHIO
www.artistsnetwork.com

THE COMPLETE GUIDE TO PAINTING WATER.
COPYRIGHT © 2008 BY BERT N. PETRI. Manufactured
in China. All rights reserved. No part of this book may be
reproduced in any form or by any electronic or mechani-
cal means including information storage and retrieval
systems without permission in writing from the
publisher, except by a reviewer who may quote brief
passages in a review. Published by North Light Books,
an imprint of F+W Publications, Inc., 4700
East Galbraith Road, Cincinnati, Ohio,
45236. (800) 289-0963. First Edition.

fw F+W PUBLICATIONS, INC.

Other fine North Light Books are available from your
local bookstore, art supply store or direct from the
publisher at **www.fwpublications.com.**

12 11 10 09 08 5 4 3 2 1

DISTRIBUTED IN CANADA BY FRASER DIRECT
100 Armstrong Avenue
Georgetown, ON, Canada L7G 5S4
Tel: (905) 877-4411

DISTRIBUTED IN THE U.K. AND EUROPE BY
DAVID & CHARLES
Brunel House, Newton Abbot, Devon, TQ12 4PU, England
Tel: (+44) 1626 323200, Fax: (+44) 1626 323319
Email: postmaster@davidandcharles.co.uk

DISTRIBUTED IN AUSTRALIA BY CAPRICORN LINK
P.O. Box 704, S. Windsor NSW, 2756 Australia
Tel: (02) 4577-3555

Library of Congress Cataloging in Publication Data
Petri, Bert N.
 The complete guide to painting water / Bert N. Petri.
-- 1st ed.
 p. cm.
 Includes index.
 ISBN 978-1-58180-968-8 (hardcover : alk. paper)
 1. Water in art. 2. Painting--Technique. I. Title.
ND1460.W39P48 2008
751.4--dc22
 2007045182

EDITED BY **KELLY C. MESSERLY**
DESIGNED BY **JENNIFER HOFFMAN**
PRODUCTION COORDINATED BY **MATT WAGNER**

ART ON PAGE 2:
WESTERN WATERFALL | OIL, 24" × 30"
(61CM × 76CM), PRIVATE COLLECTION

ABOUT THE AUTHOR

Author and artist Bert Petri has enjoyed an intriguing and fulfilling life. Born in Germany in 1925, he lived under Hitler's Nazi regime. After fighting in World War II, he escaped from a prison camp to return to Germany, which was under Russian occupation. Persecuted under communism, Bert escaped to West Berlin in 1951. His dream of finally coming to the U.S. was realized in 1956 when he settled in the Detroit area.

In Detroit Bert established an advertising agency using the art education he received in Germany. In the late 1960s he bought a farm in rural Michigan, where he pursued his lifelong ambition to work exclusively as an artist. He quickly became known in the field of art.

In 1980, Bert married fellow artist Cheri. Their union led him to new avenues of expression. The couple worked exclusively from their country studio until 1986, when they opened an art gallery to display their work. Located in the picturesque village of Pentwater on the shores of Lake Michigan, the gallery still thrives.

Best known for his nautical paintings, Bert looks to the seas for inspiration. He sailed his beloved sailboat, Kunterbunt, which means "colorful" in German, and it's here that he observed and studied the nuances of water, bringing that knowledge back to his studio.

DEDICATION

I dedicate this book to my loving wife Cheri and my children Tina, Laura and Eric.

ACKNOWLEDGMENTS

It has been said that no one is an island, meaning that no one can stand alone. Sometimes we all need help, whether from friends or family—or even strangers. My island has been inhabited by many helpers.

I'd like to thank my loving wife, who is also my angel. I often asked for her help in writing this book. I was very fortunate to get her artistic opinion and support during the process. She deserves more credit than I can ever express.

My business partner and friend, Pat Sullivan, gave me much help and did most of the photography. Besides that, he provided great moral support.

Joanne Stock, our secretary, is a jewel and I can't count the many ways she helped. Her computer knowledge saved me more than once.

I also want to thank the many customers who let me borrow paintings they've purchased over the years. They've added much to this book.

There's a parade of friends who freely provided me with hints, information, details and support. I am grateful to them all.

METRIC CONVERSION CHART

TO CONVERT	TO	MULTIPLY BY
Inches	Centimeters	2.54
Centimeters	Inches	0.4
Feet	Centimeters	30.5
Centimeters	Feet	0.03
Yards	Meters	0.9
Meters	Yards	1.1

TABLE OF CONTENTS

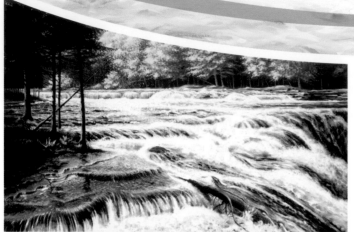

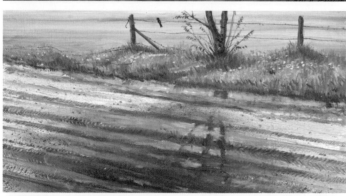
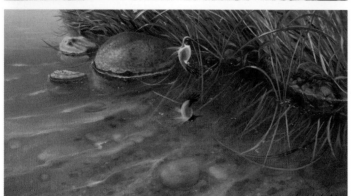
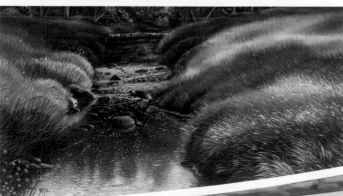

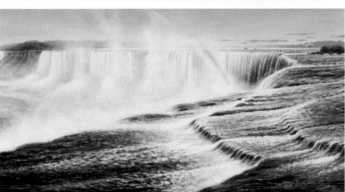

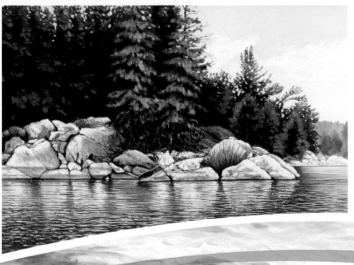

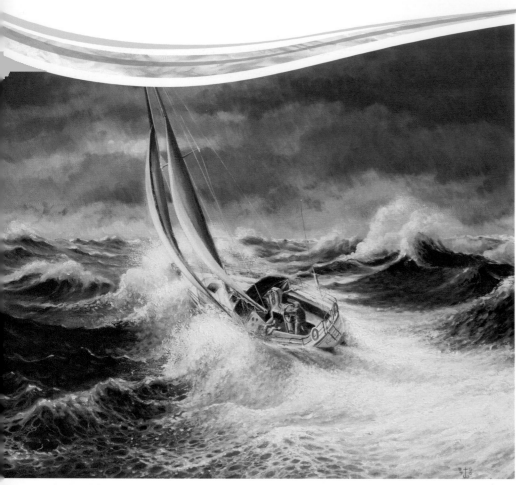

BEAUFORT SCALE EIGHT | OIL, 20" × 24" (51CM × 61CM), PRIVATE COLLECTION

It is not surprising that from the beginning of time humanity has been drawn to the waters. Humans emerged from the waters and this memory seems to linger in our psyche. It seems that the feeling, sound and motion of the liquid that surrounded us in the womb are also part of the collective psyche that binds us to the water.

Humans first settled by rivers, lakes and oceans, and from here they began to trade and explore. All discoveries and adventures began at some harbor and led them across oceans where they penetrated new continents via the rivers. In every way, humanity's destiny, love, lore and culture has been entwined with the element that covers 70 percent of the planet. It's natural that the artist within us is intrigued by water and is eager to paint it in its myriad forms, moods, colors and movements.

I'm an artist and a sailor, and for me, water has always held a special fascination. I've become known as a nautical artist, a niche I greatly enjoy. I've also been privileged to teach art. All but a few of my students have expressed the desire to paint water. Obviously, you're also interested in painting water, or you wouldn't be reading this book. I wrote this book for you and for all those who share my fascination with water.

This book is comprehensive and designed to be a guide and a reference for the professional artist and student alike. I have used an academic approach and left nothing to chance, but investigated all. I explain in detail the facts one must know in order to paint water successfully. The technique of painting

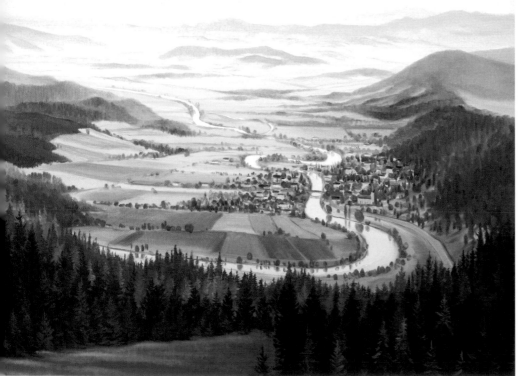

LAZY RIVER | OIL, 20" × 24" (51CM × 61CM), PRIVATE COLLECTION

water is secondary to the understanding of the nature of water itself.

In preparation for this book, I researched and exposed all that is important and left out all that is of little value. I don't talk about perspective or composition. I don't dwell on the science of color. I assume these to be prerequisites. Neither do I concern myself with the basics of painting. Many excellent books have been written on these subjects. This book is meant to teach the basics of painting water based on the nature of water itself. It can be translated into any style, technique or medium.

Water is not an easy subject to paint. It is a science. We must know the reasons for its actions and reactions. Just as medical doctors must know what makes blood run through our arteries, so artists must know the technical aspects of water if they want to paint it correctly.

This means knowing where and how waves originate, and what makes them move, increase and decrease in size. The artist must observe the color of water and know what makes it change in value and hue. She must understand reflections, perspective and light. An artist must understand why various bodies of water—from a puddle to an ocean—have their own peculiarities.

Before we approach the subject of painting water, we should concern ourselves with a very important matter, how to see properly. I've taught entire workshops on this subject. People are amazed at how little or how wrongly they actually perceive.

During my "Learning to See" workshops, I took my students on a little tour of our sixty-acre "ranch." We'd look at different textures on weathered fence posts, the growth patterns of various trees, and the variety of greens in the distant hills. Our world abounds with beauty and wonder, if only we take notice. At the conclusion of our workshop, eyes were opened to a new world.

Learning to see means to divorce yourself from what you know as fact, i.e. your reasoning abilities, and concentrate on the subject. The objective should be to see the thing only as it appears and to accept what you see and not what you think you see. What you know must never interfere with what your eyes observe. So forget what you know and begin to look. Look at everything. Ask yourself questions like: what shape is it? Which way does this line go? What does that form or shape remind me of?

Observation must be done all the time. You do not need a paintbrush or pencil in your hand. Paint and draw in your mind. You will be learning to see through seeing.

Observation and contemplation are imperative to painting any subject, but especially water. Take walks on the shore. Forget your easel. Take your time and just observe the water. Look at it from different angles, and under various weather conditions. Notice the color and depth of the water and how they relate. Climb high on a dune and move low to the beach. Look at the waves and how they move. Another time bring a pencil, do some sketching or bring your camera for photos to be looked at later.

When you have studied long enough, set up your easel. Have everything ready before you begin to paint. When all preparations are completed, think it over one more time and then start painting. It is better to paint just one good picture than several mediocre ones.

If you keep your eyes open, do some thinking on your own, follow the lessons in this book, and practice diligently, you will soon be able to master the art of painting water to your satisfaction. You must realize, however, that there are no shortcuts. Consider the world's renowned pianist who does his daily finger exercises or Michelangelo who prepared 1500 drawings for his sculpture David.

Now follow me and I will lead you through a world of amazing realizations. I will show you how to understand water through the eyes of an artist and ultimately how to paint it.

Remember what no lesser artist than Michelangelo once said:

"BEAUTEOUS ART, BROUGHT WITH US FROM HEAVEN, **WILL CONQUER NATURE:** SO DIVINE A POWER BELONGS TO HIM **WHO STRIVES WITH EVERY NERVE."**

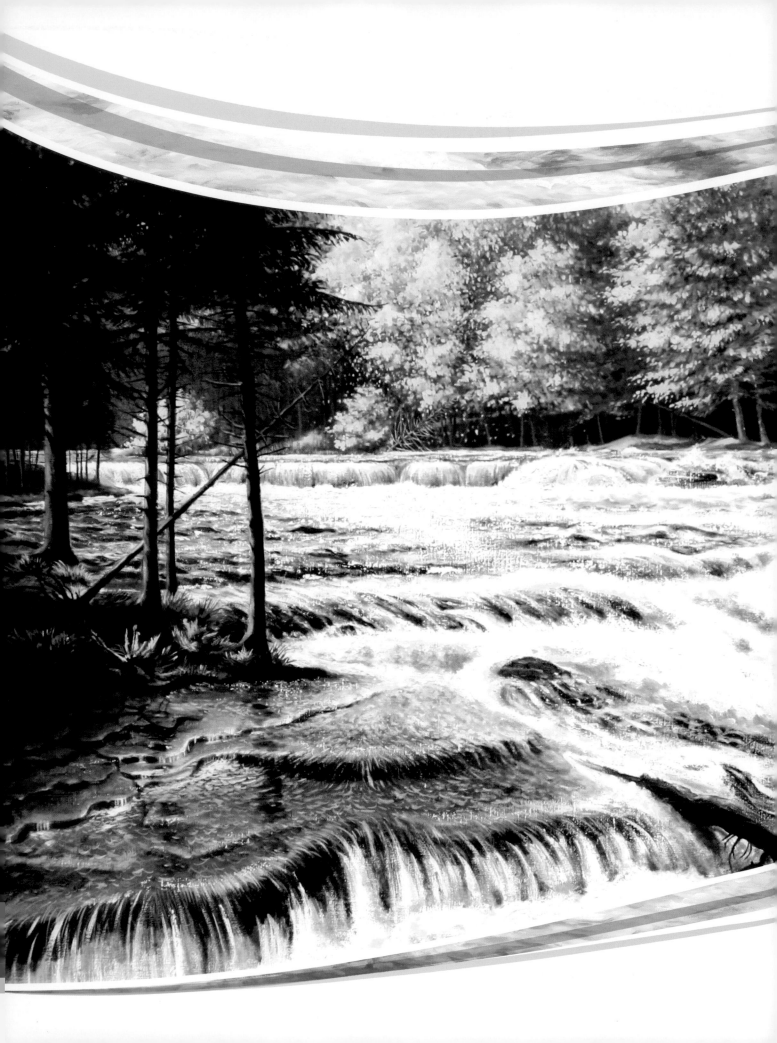

MATERIALS

Nothing is more exciting—or daunting—than entering a large art supply store. Colors seem to call out to us, and we want to buy every brush in the place. Most of us, however, don't have deep enough pockets for that kind of shopping experience. Instead, we must decide which brands, brush sizes and colors to pick.

The materials and tools you select when you first begin to paint are critical. They can make the difference between success and failure. Never skimp with cheap materials if you are serious about learning. The well-known brands are worth the price, but experiment to see which brands work best for you.

After years of painting, I have determined which colors work best for me. I know what they will do when mixed together or put side by side. Also, I have favorite brushes that suit my style. In the following pages I will share my top preferences with you. But don't be afraid to experiment with other materials and colors. Ultimately, each artist must find what works best for them.

Once you've purchased your materials, it's important to care for them properly. Don't let your brushes dry out, and be sure to tighten the caps of all paint tubes. Get in the habit of taking care of your brushes and paints at the end of the day. They will serve you better and last longer.

CHAPTER ONE

TAHQUAMENON FALLS | OIL, 40" × 60" (102CM × 152CM), PRIVATE COLLECTION

PAINT

All paint colors are made of the same pigments. These pigments usually come from nature, but can also be made synthetically. For instance, Raw Sienna comes from the earth around Sienna, Italy. Burnt Sienna is achieved when Raw Sienna is burned. The component that makes each paint medium different is the binder. Binder holds the pigment colors together and allows the pigments to adhere to a surface. For oil paints, the binder is oil; for acrylic paints it is a plastic substance such as latex; for watercolor paints it is gum arabic.

I generally use a limited palette for all my paintings, whether the medium is oil, acrylic or watercolor. Some colors are opaque and work well for covering an area. Other colors are transparent: Alizarin Crimson and Viridian for example. These colors work well as glazes because they allow the color underneath them to be seen.

Watercolors are generally transparent, and acrylics can be used either with an opaque or transparent technique. The more you paint, the more you'll find out exactly how each color acts alone and when mixed with other colors.

The primary colors (of course) are red, yellow and blue. There are, however, many kinds of reds, yellows and blues available. In addition to primary colors, earth tones such as Burnt Sienna, Yellow Ochre and Raw Umber are staples for any artist's palette.

FOR AN EXPANDED PALETTE TRY:

Cadmium Red (acrylics)
Ivory Black (acrylic and watercolor)
Mars Black (oils)

COLOR PALETTE

Cadmium Yellow Light—a bright opaque yellow.

Cadmium Yellow Medium—a bright, opaque yellow that's slightly darker than Cadmium Yellow Light.

Cadmium Orange—a brilliant, opaque orange.

Cadmium Red Light—a brilliant, opaque red.

Alizarin Crimson—a vibrant, transparent deep red that tends toward purple.

Yellow Ochre—an opaque yellow that tends toward brown.

Burnt Sienna—a semitransparent reddish brown earth color.

Raw Umber—a semitransparent dark brown earth color.

Payne's Gray—a transparent gray that tends toward blue.

Prussian Blue—a powerful, transparent blue that tends toward green.

Ultramarine Blue—a semitransparent blue.

Cobalt Blue—a semitransparent clear blue.

Cerulean Blue—an opaque greenish blue.

Viridian—a bright transparent dark green that tends toward blue.

Permanent Green—an opaque green.

Phthalo Yellow Green—an opaque, very bright yellow-green.

Titanium White—an opaque white that I use in my oil and acrylic palette.

Chinese White—an opaque white that I use in my watercolor palette.

ARRANGING YOUR PALETTE

A palette is where you place and mix your paints. It should be placed so that it's easily accessible—either directly in front of you or to the right (if you are right-handed) or to the left (if you are left-handed). Having a well-organized palette before you begin will mean that you're not losing your concentration by having to hunt for paints.

OILS

I often say that I could actually paint in the dark and know exactly where my colors are because I have a specific way of arranging my palette each time I paint. It's best to come up with your own system and stick with it so you eliminate the need to hunt for the pigment you want. Otherwise, you'll be distracted from the job at hand, which is painting.

When working in oil, I use a wooden board attached to the canvas support of my easel. You can also use a board that's not attached and simply place it on a table next to your easel. (A sheet of glass, Plexiglass or an enameled tray can

be substituted for wood.) Have three jars sitting directly to the right on your palette. The first bottle should contain dirty turpentine for cleaning brushes. The next bottle should contain clean turpentine for thinning paints. The third bottle, the one nearest you, should have a mixture of two parts Liquin to one part turpentine. This painting medium can be used to thin oil paints and speed up drying time.

On the palette itself, place a glob of white paint on the far right, followed by yellows, oranges, reds and earth tones. After that, place blues, then greens, then black on the far left.

Keep several rags on hand. Rest the brushes you're using on a folded rag and keep other brushes on top of a rolling taboret. Arrange your painting tubes in drawers for easy access. Turpentine and extra rags can sit under your easel on a shelf. You can also lean your mahlsticks up against the easel to the left. This arrangement is convenient and works well for me.

WATERCOLORS

For watercolors, a standard plastic palette with about twenty-two small wells around the edge works well. Arrange the colors as you would for oil painting. Keep other supplies such as masking fluid, sponges, paper towels and water containers next to your work surface.

ACRYLICS

Acrylics are flexible and can be used either like oils or watercolors. The palette used for acrylics depends mainly on how you intend to paint. If you like to use acrylic thickly like oil, use a palette similar to an oil palette. If you plan to paint with the acrylics thinned in a manner similar to watercolor, use the palette similar to the one you would use for watercolor. Keep large containers of water handy for cleaning brushes. You may also use a retarding medium. Place these on a table near your palette, or directly on your palette if you have room.

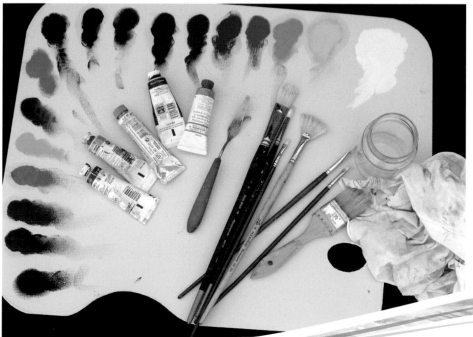

OIL PALETTE SETUP
Here you can see the jar of turpentine set up on my palette. The paint tubes are sitting on the palette in the order in which I place them on the palette. Make sure your palette is large enough for you to place and mix your paints.

BRUSHES

Brushes are some of your most important tools. With so many brush types available, it can be difficult to choose the best brushes for a particular project.

Basically, brushes are identified by shape, size and the material from which they are made.

The basic brush types include:

- *Flat.* These have square ends with medium to long bristles. Use these for bold strokes and filling in large areas.
- *Bright.* Similar to the flat, but the bristles are shorter. They offer more control than the longer flat.
- *Angular.* As the name suggests, the bristles are shaped as an angle. They work well for large areas or details.
- *Filbert.* Oval-shaped brushes with medium to long hairs. Good for blending.
- *Round.* The bristles are placed in a round ferrule with a pointed tip. Used for detail.
- *Liner.* Similar to a round brush, but the bristles are very long. Good for long, continuous strokes.
- *Blender.* This is also known as a *fan* because the bristles are placed to resemble a fan. Used for blending and special effects.

The material from which the brush is made is also a consideration. Brushes can be made of natural materials such as hog bristle, sable and camel. They can also be made from synthetic filaments such as nylon or polyester. The common name for these filaments is "Taklon." These are only appropriate for use with watercolors and acrylics.

Finally, the brush's size is also important. Brushes are generally numbered from small (00000) to large (18). A small brush would obviously be needed for small areas or fine detail and a large brush would be more appropriate for covering large areas.

BRUSHES YOU'LL NEED

With these brushes, you can do any of the demonstrations in this book.
- *1½-inch (38mm) and 1-inch (25mm) flat house-painting brush*
- *No. 4 angular Taklon*
- *Nos. 6 and 8 hog bristle blenders*
- *Nos. 0, 2, 4, 6, 8 and 10 hog bristle brights*
- *Nos. 0, 1, 2, 4, 6 and 8 sable rounds*

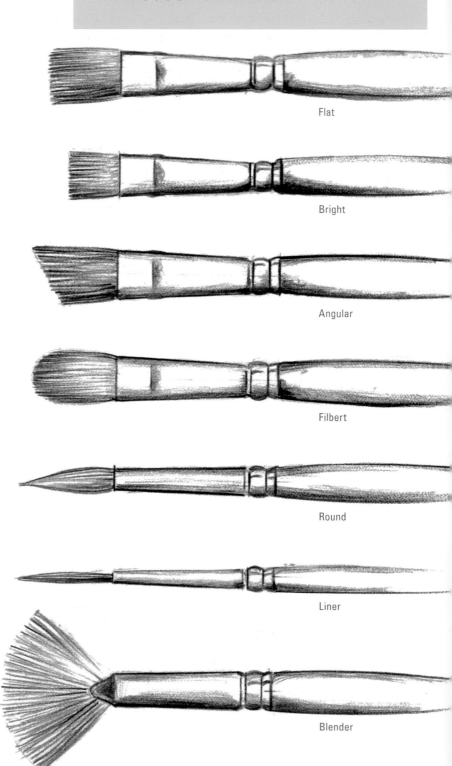

Flat

Bright

Angular

Filbert

Round

Liner

Blender

SURFACES AND EASELS

OIL

My choice of canvas is primed cotton duck with a medium texture, with two additional coats of white gesso applied over it. I usually stretch my own canvases, but you can purchase ready-made canvases at art and hobby stores. Sometimes I use Masonite, which I have cut to a specific size, and then coat with three or four coats of gesso.

WATERCOLOR

I use 300-lb. (640gsm) Arches Bright watercolor paper in size 22" × 30" (56cm × 76cm). This paper is so heavy that it never buckles and never requires soaking or stretching. Simply tape the paper to a separate piece of 30" × 40" (76cm × 102cm) plywood so you can move it around, or set it up vertically without moving the entire table. However, you should experiment with other brands to see what works best for you.

EASELS

You can do most of your oil and acrylic work on easels. The easel you use depends on the size of the painting and whether you're working in your studio or on location. Studio easels with a built-in palette located below the painting area are most convenient.

For watercolors work on a 40" × 60" (102cm × 152cm) adjustable drafting table covered with Formica, which is easy to clean.

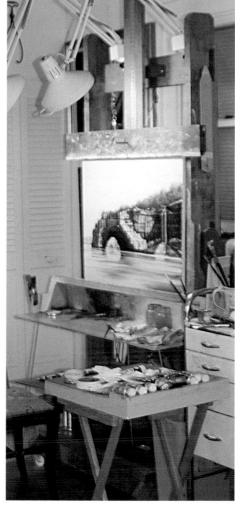

EASEL

This is my easel, which I have set up in my studio all the time. There is a window opposite the easel for natural light and several artificial lights above for more light. My paints, brushes and all other materials I might need are next to my easel. I never have to hunt for anything! This leaves my mind free to create the painting.

ACRYLIC SURFACES

Because acrylic is a flexible medium, you can use it to paint on just about any surface—canvas, Masonite and watercolor paper are just a few.

BASIC **FACTS** ABOUT **WATER**

When deciding to paint water you must consider some basic facts, principles and conditions concerning it. It's not enough to simply follow a set of demonstrations.

True knowledge comes from study and observation. You must understand water and why it behaves in certain ways to paint it successfully.

Have you ever sat at the beach and watched the waves as they flow towards you and then retreat back to the sea? You see the waves and yet you don't really see them. If you observe them as an artist does, you begin to see the nuances of color. You contemplate the shapes that make up each wave as it builds and then comes crashing in. Your mind attempts to understand and create a pattern. This is the mind of the artist.

The artist and the scientist have much in common. The artist, like the scientist, must make careful observations. The artist comes up with conclusions based on his observation much like a scientist does. We can use our observations and those of the scientists to better understand our subject. But the artist goes one step further. She takes that knowledge and re-creates the subject on canvas or paper. She makes the subject believable because she bases it on observation and fact.

I can usually tell immediately if artists have spent time learning about or observing water. An immediate tip-off is the tilted horizon of the water. If they knew much about water they would know that water always seeks to be level. This is a basic fact about water which cannot be changed.

In this chapter, you'll learn basic facts about water. Some of the information may seem self-evident or remedial, but don't skip by. The time you spend contemplating the nature of water will lead you to an understanding of this interesting subject. In later chapters I will show you how to translate that knowledge to the painting of water whether it be in oil on canvas or any other medium you may choose.

BY THE EDGE | OIL, 24" × 30" (61CM × 76CM), COLLECTION OF JANICE AND ELLIE MJOVIG

WATER IS FLUID

Water in its liquid state is neither solid nor constant. It moves in all directions—up and down, forward and backward, to the right and to the left. It flows around objects, falls down and forms pools. It conforms to the shape of the object that contains it. If it's held in a glass it becomes the shape of the glass. The great Colorado River is held in by the cliffs that surround it.

One of the best ways to observe the fluidity of water is to observe a river. The water flows along the river because the banks are holding it in. If the water were to get too high, it would flow over the banks. If there is a sudden shift of the ground level, the water will fall creating a waterfall.

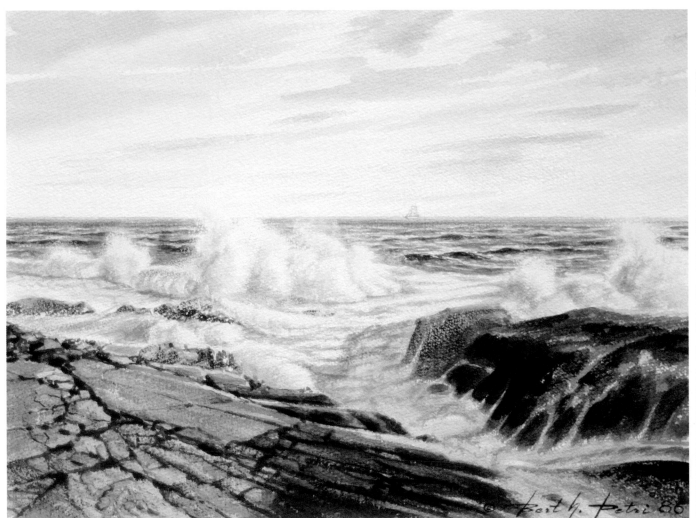

ROCKY SURF | WATERCOLOR, 16" × 20" (41CM × 51CM), COLLECTION OF JANICE MJOVIG

FLUIDITY IN OCEANS
As the ocean water moves closer to the shore, it crashes onto the rocky coast. You can see the water running over and trickling down and around the rocks while the force of the surf draws the water back to the sea.

WATER SEEKS TO BE LEVEL

Due to the force of gravity and the fluid nature of water, it will always seek to be level. That means that water is constantly moving and trying to find balance or a horizontal plane. It will do anything it can to find that balance, including running over anything in its path. To study water you must be aware of this phenomenon. If the water in your painting is not level, it will seem to the viewer that the water could run off the picture plane.

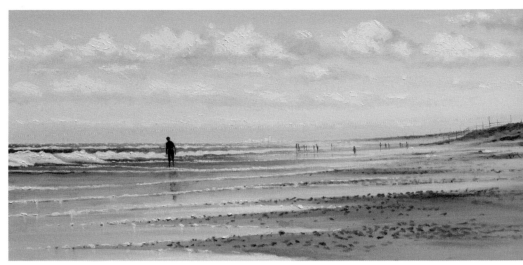

FLORIDA'S EAST COAST | OIL, 24" × 30" (61CM × 76CM), PRIVATE COLLECTION

A LEVEL HORIZON
In a large body of water such as the ocean, all of the water seeks to be level despite the varied depths below. When painting the horizon you must always make sure the water is level on the picture plane or the entire painting will look wrong.

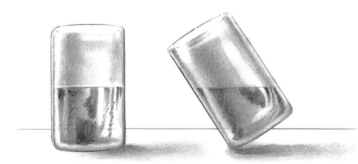

TILT WATER TO OBSERVE ITS LEVELLING QUALITY
Take a glass of water and tilt it to the side. The water contained in the glass will remain level even though the glass has been tilted. No matter how much the glass is tilted, the water will stay level. If the water is tipped too far, it will run out of the glass and seek to be level on the next surface.

WATER RUNNING OVER BARRIERS
While water is moving and seeking to be level, it sometimes meets obstacles. Water will always choose the easiest route around or over the object. As the water falls over the rocks in this illustration, it fills the area and becomes a small pool. The water in the pool remains level until too much water has been added to allow it to do so. At that point, the water will run over the next rock and the process is repeated.

WATER IS TRANSPARENT

Pure water, without any pollutants or additives, is inherently transparent. Because of the see-through nature of water, you can see what is under or behind it. If you have a glass of water in front of a blue wine bottle, you can see the blue through the glass on the other side. If you are on a dock looking down into the water, you can see the pebbles and creatures clearly in the shallow water below. This transparent nature is important for the artist to understand and be able to re-create. If you want to paint the edge of a stream or lake you'll need to be able to depict transparent water. I'll show you how to re-create this effect in your paintings.

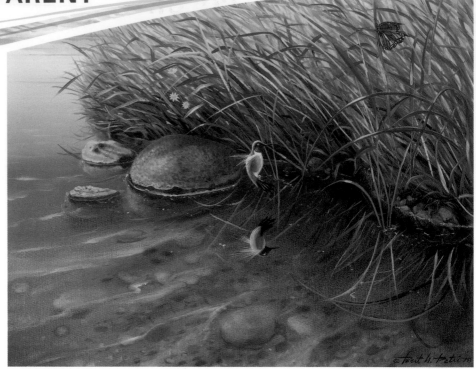

BY THE EDGE | OIL, 24" × 30" (61CM × 76CM), COLLECTION OF JANICE AND ELLIE MJOVIG

SHALLOW WATER
Take the time to observe the shallows at the edge of water. In the painting above, you can see the ground below the water. To indicate shallow water, first paint the ground under the water a shade darker than ground not covered by water. Let the painting dry, then add some soft white streaks to suggest reflections of light on ripples. The reflection of the hummingbird, grasses and rocks also convince the eye that we are looking at water.

DEPTH AFFECTS VISIBILITY
Here you can see that the water appears lighter in the background, while the water in the middle ground appears darker. In the foreground you can see through the water to the ground below.

WATER DARKENS OBJECTS
As you can see, the objects below the water are several shades darker than the ground not covered by water.

DEEP WATER
Here you can see the deep water with the light streaks of reflected light on top.

WATER CAN HAVE COLOR

That water can have color may seem like a contradiction considering that water is transparent. Yes, water is transparent; however, water can have color. More often than not, water is picking up other particles that float around in it. The color of water can also be affected by pollutants. We have all seen greenish-yellow lakes that are not fit for swimming. When painting water you must carefully observe its color.

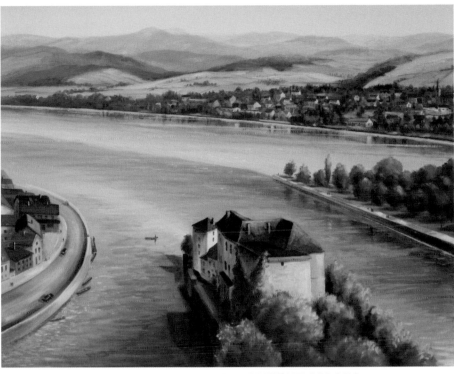

THREE RIVERS | OIL, 22" × 28" (56CM × 71CM), PRIVATE COLLECTION

DIFFERENT BODIES OF WATER HAVE DIFFERENT COLORS

Here three rivers in Passau, Germany—the Ilz, the Danube and the Inn—converge. You can clearly see that all three rivers are different colors. The origins of the rivers and the geological terrain through which they pass before reaching this point are responsible for their differences.

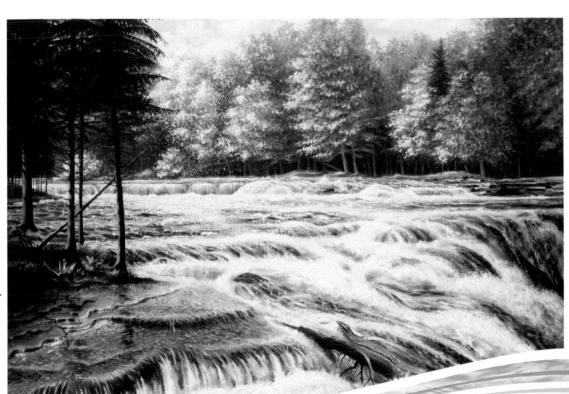

TAHQUAMENON FALLS | OIL, 40" × 60" (102CM × 152CM), PRIVATE COLLECTION

WATER GETS ITS COLOR FROM THE OBJECTS IN AND AROUND IT

The Tahquamenon Falls in the Upper Peninsula of Michigan have a definite color. This is caused by the cedar swamps where the river originates which tint the water a reddish brown.

WATER IS REFLECTIVE

Water in general, and still water in particular, behaves like a mirror. Even bodies of water with ripples or waves act as a mirror. Understanding and mastering the art of painting reflections will enable you to paint believable water.

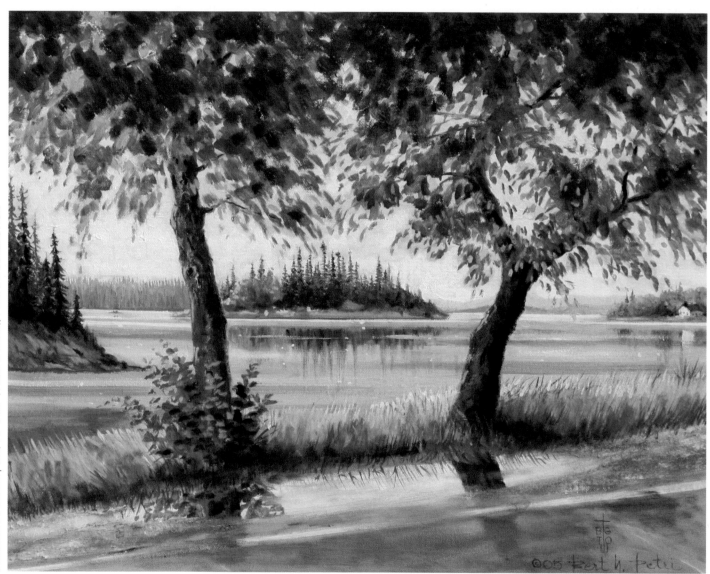

PUDDLE BY ROAD | OIL, 16" × 20" (41CM × 51CM), PRIVATE COLLECTION

REFLECTION SUBTLETIES

This painting illustrates water's reflective quality. The two trees beside the road are both reflected in the small puddle. Notice that the reflection of each tree is angled opposite the actual tree. Also, observe that reflections always come towards the viewer. If you were actually on this road and moved to the right, the reflections would move as you moved. Notice that even in the background the water is behaving like a mirror, reflecting the islands and the house.

WATER REFLECTS THE COLOR OF THE SKY

The general public believes that the sky is blue. However, the sky can be many colors. The reds, yellows and purples of the sunset and the gray-green of an approaching storm are only two examples of the variety of colors you can observe in the sky. The water below the sky will then reflect the color of the sky above it. The artist must observe the color of the sky and use this same color when painting the water below.

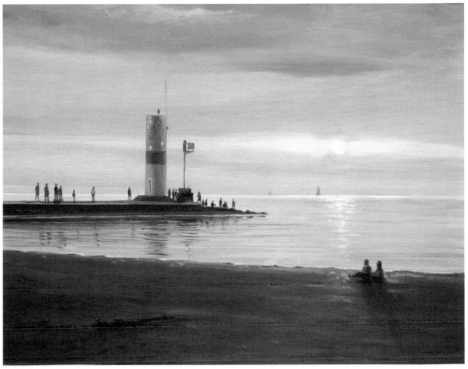

ORANGE SKY, ORANGE LAKE
People gather here at the lighthouse to watch the sun set. The same brilliant warm oranges, reds and purples that light up the sky are reflected in the lake.

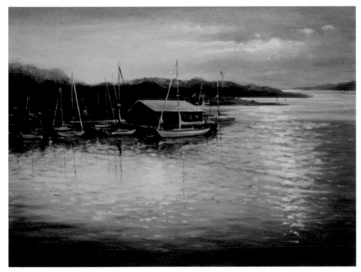

MOONLIGHT | ACRYLIC, 16" × 20" (41CM × 51CM)
PRIVATE COLLECTION

MOONLIT SKY, MOONLIT HARBOR
Moonlight gives both the sky and the reflective water a purple hue. As the light from the moon flickers from behind the clouds, it casts diamonds of light on the water below.

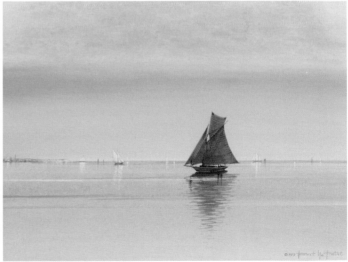

BECALMED | WATERCOLOR, 20" × 27" (51CM × 69CM)
PRIVATE COLLECTION

GREEN SKY, GREEN OCEAN
A green sky is a sign of bad weather ahead. This sailing vessel barely moves as the calm waters mimic the green of the sky.

YOUR **POSITION RELATIVE** TO WATER IS **KEY**

The angle at which you see water is important for two reasons. First, the angle changes how much of the image you can see. The lower you are, the more the water will act like a mirror, reflecting the objects on it. The higher you are, the less you will see of the object's reflection.

The angle at which you see the water also affects the value, or relative lightness or darkness, of the water. The value of the water will be darker the higher your position is relative to the water.

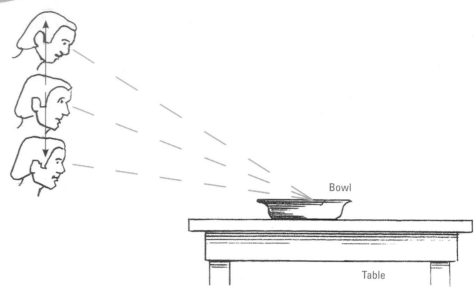

Bowl

Table

POSITION EXPERIMENT

For this experiment, take a medium-value plastic bowl filled with water outside and place it on a table. Raise and lower your position in relation to the bowl. Notice that the lower you are in relation to the bowl, the lighter the reflection on the water and the truer the water is to the color of the sky. The higher your position, the darker the water's surface will appear. If you are directly over the bowl, the water's surface will seem two or three shades darker than the bowl itself.

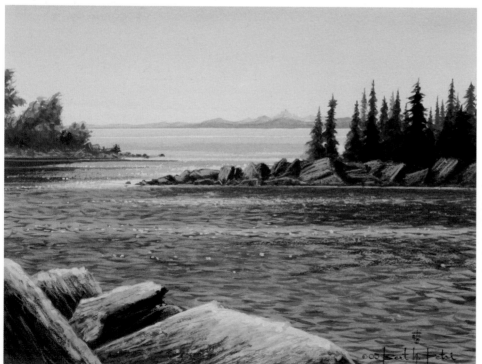

DIFFERENT REFLECTIONS

This painting of a relatively still lake illustrates the way water's value changes with your angle. The water that you can see far in the distance is light because you are seeing it from a low angle. The water closer to you is darker because you see it from a higher angle.

NORTHERN LAKE | WATERCOLOR, 12" × 16" (30CM × 41CM), PRIVATE COLLECTION

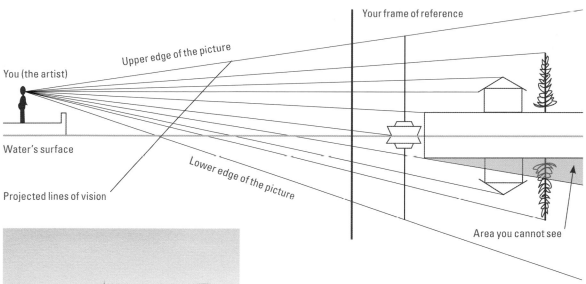

YOUR POSITION DETERMINES WHAT YOU SEE

Here your elevation is very low to the surface of the water. Very little of the reflection is lost (as represented by the shaded area) and you have an almost perfect mirror reflection.

You (the artist)

Your frame of reference

Upper edge of the picture

Water's surface

Lower edge of the picture

Projected lines of vision

Area you cannot see

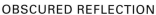

OBSCURED REFLECTION

In this painting of a relatively still lake, you can see that the water far in the distance is light reflecting the light sky. The water nearer to you is darker and only part of the boat's mast is visible.

THE ANGLE AFFECTS VALUE

Everything is the same as the illustration above, except that your elevation is raised. Because of this, more of the reflection is lost.

It's not necessary to map out every reflected object this way, but it is important to know how vantage point affects what you and your viewers can see.

You (the artist)

Upper edge of the picture

Your frame of reference

Water's surface

Lower edge of the picture

Projected lines of vision

Area you cannot see

ALMOST PERFECT REFLECTION

Notice the almost perfect reflection of the boat. From this angle, you can also see more of the objects on land.

WATER IS AFFECTED BY LIGHT

As artists we rely on light to define forms, create dimension and suggest a mood. Light is also an important part of the equation when you are trying to paint water. The effect that light has on your visual perception of water is varied and is worth studying. Basically, the closer a subject is to the source of light, the brighter or lighter it will become.

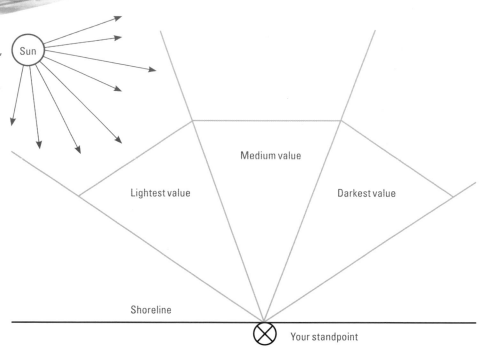

THE SUN'S EFFECT ON VALUES
As the sun descends in the sky its rays penetrate the atmosphere at an angle, and the distance the rays must travel through the atmosphere is decreased. When the sun is very close to the horizon, it appears very bright. The water just below the sun will be lightest and become darker the farther away it is from the sun.

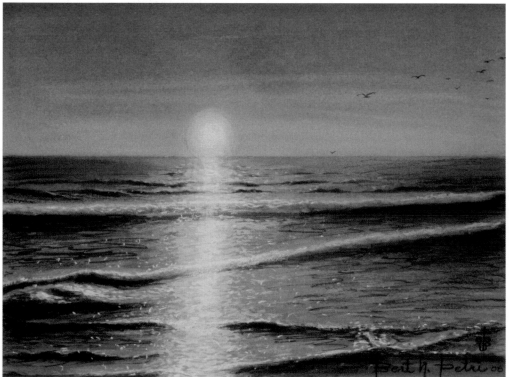

NORTHERN VIEW | WATERCOLOR, 12" × 16" (30CM × 41CM), PRIVATE COLLECTION

INTENSITY OF LIGHT
This painting beautifully illustrates how light gets more intense as the sun gets closer to the horizon. The sun casts a strong vertical light directly below onto the water. On each side of this vertical light, the intensity of light diminishes until it becomes quite dark on the perimeters of the painting.

THE SUN'S POSITION

When the sun is high in the sky at noon, it shines indirectly onto the earth's surface and its rays of light are widely scattered, illuminating the largest area of the earth relative to our position. The water takes on a more general lightness without the dramatic changes in value we see at sunset. At sunset, when the sun is low, the darks and lights are in strong contrast. In the morning or early evening, the sun casts warm light on the water.

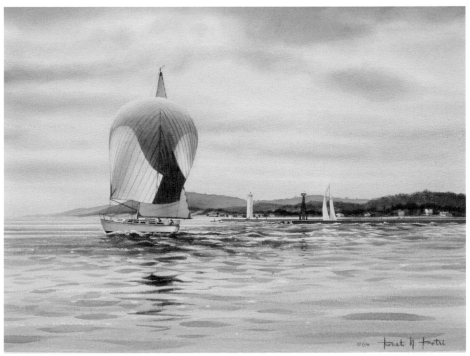

SPINNAKER | WATERCOLOR, 20" × 24" (51CM × 61CM), PRIVATE COLLECTION

EARLY MORNING SUN

The sky has a pinkish hue, which is reflected in the water. The lower angle of light creates soft contrasts of dark and light on the waves.

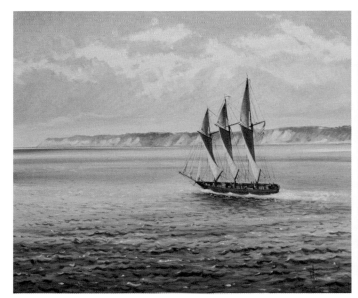

OFF CAT'S HEAD | OIL, 20" × 24" (51CM × 61CM)
PRIVATE COLLECTION

LIGHT AT MIDDAY

Because the sun is high, the water in this painting is of medium value. Notice, however, that the water gets darker in the lower edge of the painting because the viewer is seeing it from a high position relative to the water.

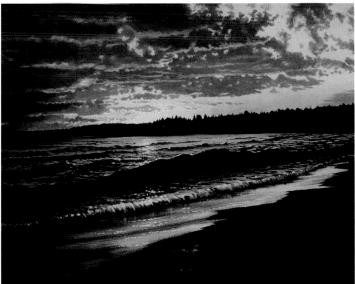

DAY'S LAST LIGHT | OIL, 24" × 30" (61CM × 76CM)
COLLECTION OF JUDITH VANKAMPEN

SUNSET

You can't get more dramatic than this. As the sun sets the lights and darks on the water become more intense.

NATURE **AFFECTS WATER**

The surface of water is seldom still. It is disturbed by winds and storms, usually resulting in the formation of ripples or waves. A light wind will cause ripples, while a more substantial wind will cause waves. The effect of a full-blown storm causes huge breakers. Tides, with their constant ebb and flow, create a myriad of treasures on the beach as they retreat. All of us can remember watching circles expanding out from the drops of rain on the water's surface. These are but a few of the ways that nature makes an impact on water.

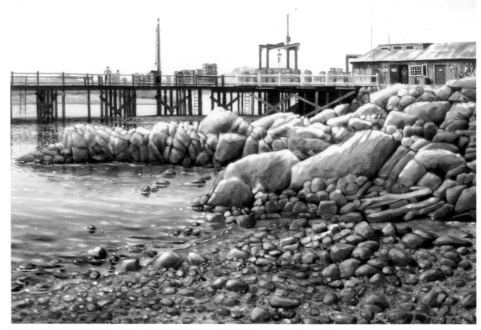

LOBSTER PIER | OIL, 22" × 28" (56CM × 71CM), PRIVATE COLLECTION

LOW TIDE
This painting of the Maine coast shows the result of low tides. The muddy bottom and wet seaweed hanging on the rocks are typical of low tide. Use Raw Umber for the mud and green gray made with Viridian and Raw Umber for the seaweed.

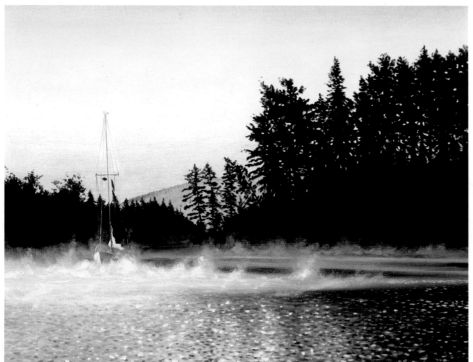

FOG IN BAY FIN | OIL, 15" × 22" (38CM × 56CM), PRIVATE COLLECTION

LOW LIGHT, SOFT CONTRASTS
In this early morning scene of Lake Michigan, the sky has a pinkish hue which is reflected in the water. The lower angle of light creates soft contrasts of dark and light on the waves.

BODIES OF WATER VARY IN SIZE

The size of the body of water determines to a great extent how it behaves. A pond or small puddle will generally be still and act much like a mirror. A small lake will often have ripples and small waves, but not large whitecaps. Large, rolling swells and waves exist mainly in the oceans and the Great Lakes.

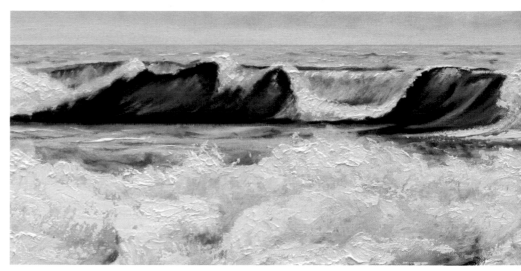

OCEAN FURY (DETAIL) | OIL, 24" × 30" (61CM × 76CM), COLLECTION OF THE ARTIST

OCEAN SWELLS
The large breakers in this painting can only exist in a large body of water such as an ocean or one of the Great Lakes.

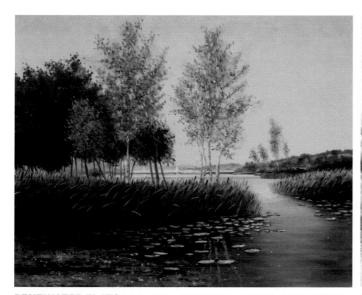

PENTWATER FLATS | OIL, 24" × 30" (61CM × 76CM), COLLECTION OF THE ARTIST

SMALL BODY OF WATER
The edge of this small lake is perfectly still much like a pond. The trees are mirrored in the water under the water lilies.

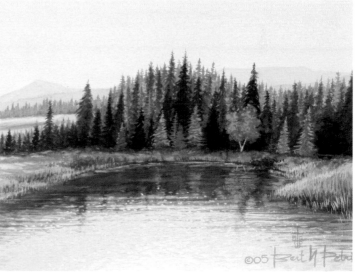

COUNTRY POND | WATERCOLOR, 12" × 18" (31CM × 46CM), COLLECTION OF THE ARTIST

POND
This small pond is very open and has enough area for the wind to produce small ripples. These ripples break up the reflection of the trees.

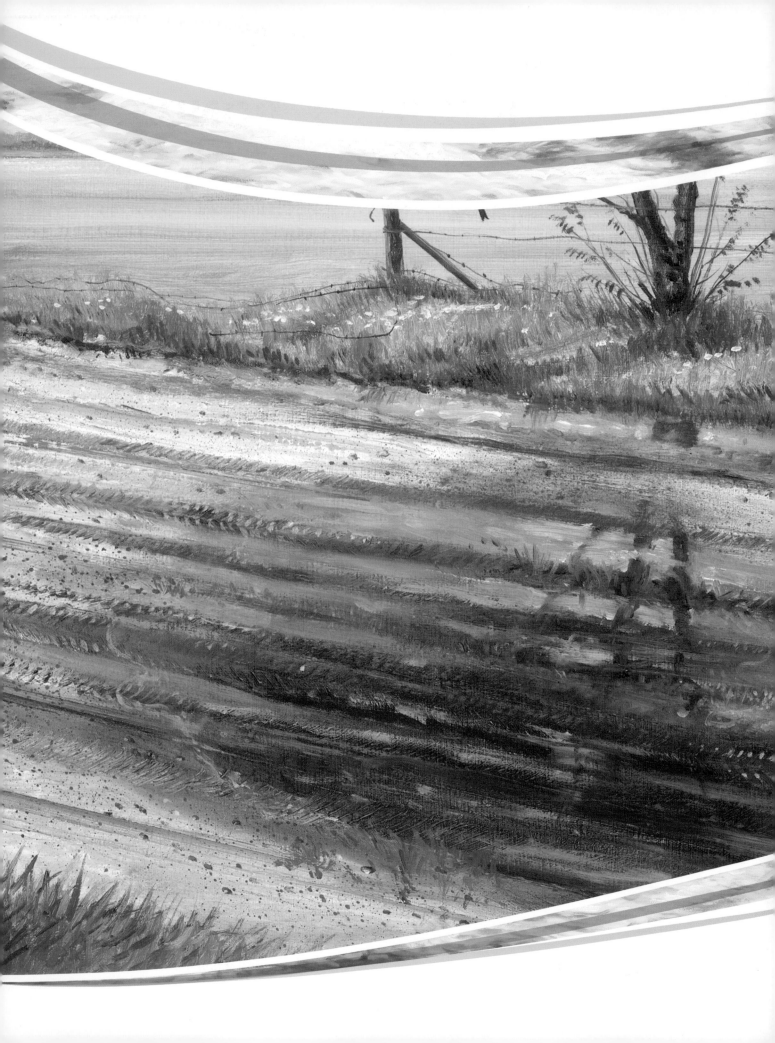

PUDDLES, PONDS AND SMALL LAKES

Learning to paint reflections is one of the most important aspects of painting realistic water. Because they are usually still, smaller bodies of water give us the best opportunity to study and learn how to paint reflections correctly. In this chapter on puddles, ponds and small lakes, I will show you how to capture the essence of this phenomenon.

Picking the perfect image you wish to paint is always the first consideration in painting any subject. I have traveled extensively both by land and by sea. This has provided me with a wealth of inspiration and knowledge that will provide me with good information for the rest of my life. It would be good for you to start building a water file for reference. Normally I search for something in a photo or sketch that depicts a mood I want to express. Still water gives most viewers a feeling of calm. I always look for a focal point to which the eye will be led. This might be a branch hanging over the water casting its reflection below or the light flickering through the trees. Whatever it might be that catches your eye, as an artist it's important to recognize and then work towards re-creating it on canvas or paper. The goal is for the viewer to see the scene as you saw it and feel as you felt.

As you begin to explore the ponds and puddles around you, remember to take your time in observation. Notice the nuances of change in the water's surface texture and color. Pay attention to the reflections and how they change as you change your position. Notice how the color of the sky is reflected in the water and how the foliage and grass on the edge is repeated again on the water's surface. Keep a sketchbook or camera nearby when you are outside. We often think that we will remember a scene, but our memories quickly fade.

Once your observation is complete you can begin to paint. In this chapter I will show you how to paint the reflections you see. I will give you information that will enable you to re-create the enchanting scenes you've observed. If you take your time and follow the demonstrations, I think you'll be pleased with your results.

PUDDLE IN THE ROAD | OIL ON CANVAS, 16" × 20" (41CM × 51CM), PRIVATE COLLECTION

HOW **REFLECTIONS** WORK

Perfect reflections require water with no movement. These are the days when there isn't a breeze in the air. You can clearly see reflections in the water and create a perfect replica of the scene in reverse.

On days when there is a breeze, you'll see a reflection that is chopped up by small waves. It's like taking the reflection and dividing it up into many long slices and then spreading them out with spaces in between.

On a small lake you will occasionally see no reflection at all. This happens when the surface is disturbed by a constant wind. The many small ripples are angled in a way that prevents you from seeing any reflection. In this case, the general color of the water will not be that of the sky. The reason is the structure of the individual waves. Each wave has two horizontal and two tilted surfaces. The horizontal surfaces reflect the light sky and the two tilted, larger surfaces allow us to look into the darker, deeper water.

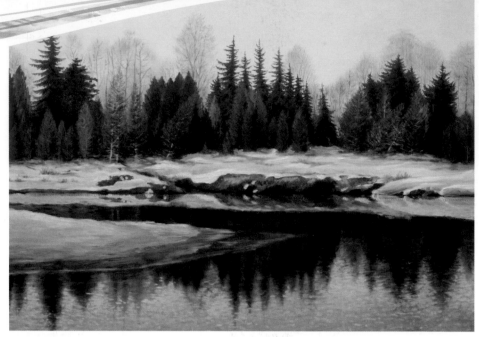

WINTER POND | OIL, 36" × 48" (91CM × 122CM), PRIVATE COLLECTION

PERFECT REFLECTIONS
When painting this winter scene, I painted each tree's reflection directly below it. Some of the lower trees were not painted because the bank of snow prevented me from seeing their reflection. I used a blender brush with a horizontal stroke over the reflections to give them the blurry effect I was after.

BLURRED REFLECTIONS
The reflection of the rocks and trees is chopped up and spread out towards the bottom of the painting. I used the same colors that I used to paint the trees in the reflection. In the reflection, however, I used horizontal strokes the same color as the trees, leaving the color of the water between the reflection.

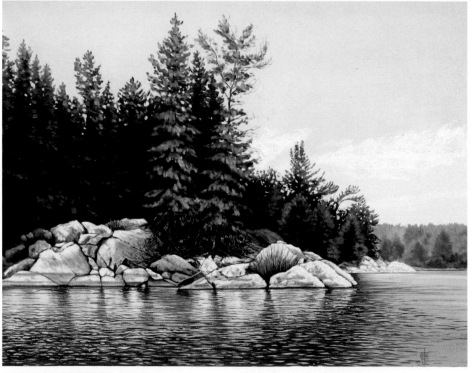

ENTRY TO PORTAGE COVE | OIL, 20" × 24" (51CM × 61CM), PRIVATE COLLECTION

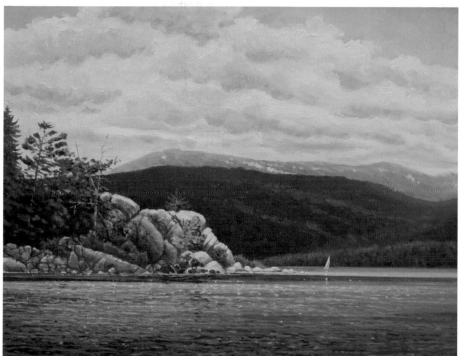

NO REFLECTION

On a small lake, you occasionally see no reflection. Once I had put in the water, I added light reflections in the back and a dark streak underneath the rocks. I created the water closer to the viewer with many little horizontal strokes of different colors.

REFLECTION LOSS

As you learned in chapter 2, we do not always see everything in a reflection. If we are at a higher angle, the object is far back from the edge of the water or part or all of it cannot be seen. Here we see only part of the farmhouse and tree. We see only the very top of the silo next to the barn because they are both much farther back from the water.

NORTH CHANNEL SCENE | OIL, 16" × 20" (41CM × 51CM), PRIVATE COLLECTION

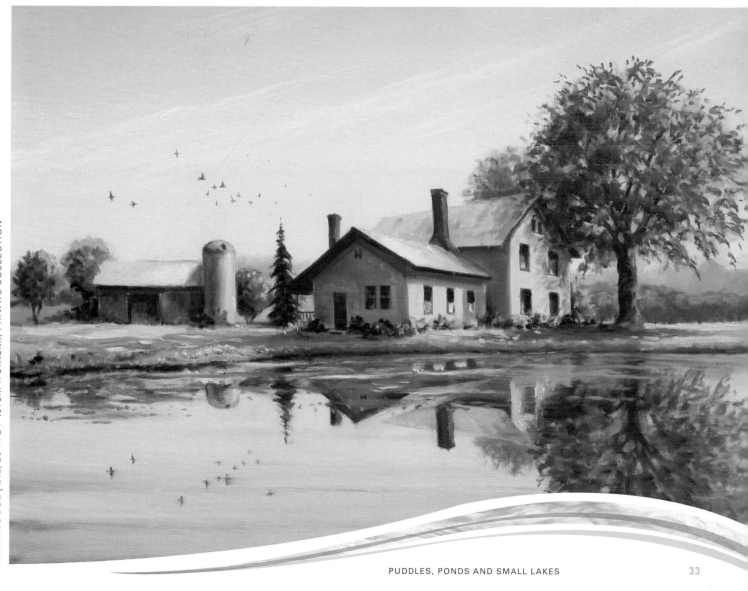

FARMHOUSE | OIL, 20" × 24" (51CM × 61XCM), PRIVATE COLLECTION

PAINTING REFLECTIONS

When painting a perfect reflection you can paint the scene upside down with the color of the reflections generally darker than the real scene. It's also best to use horizontal strokes as much as possible to add to the smoothness of the water.

There are two methods that work well when painting reflections with small movement in the water: the horizontal stroke method and the zigzag method.

TO BLEND OR NOT TO BLEND?

Both the horizontal stroke and zigzag methods can be left on the surface as they are in a watercolor painting and they will bleed into the other colors. In an oil painting and when working wet-in-wet in acrylic, you must blend the wavelets using a blender brush.

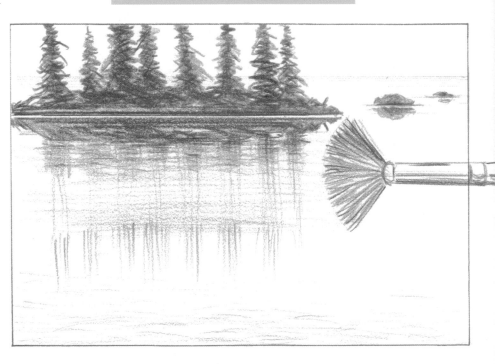

REFLECTIONS IN OILS

Lightly work the blender horizontally across the water, alternating your strokes from left to right and right to left. This is important because if you only blend in one direction the actual image of the reflection will be pushed or shifted to one side with every stroke you make. For each stroke you make to the right, you need to make one stroke to the left.

THE HORIZONTAL STROKE METHOD

Practice making strokes like these using a small sable round brush. The consistency of your paint should be what I can only describe as "soupy." To paint, gently put the brush down on the surface, pull the brush horizontally as you increase pressure, release the pressure again and lift the brush. Your individual strokes will look like this.

THE ZIGZAG METHOD

Another way to achieve a similar effect would be to make a very fast zigzag line or wavy line with a sable round brush. Using the same "soupy" mixture and the small sable round brush, work horizontally, trailing the line out at the bottom. The line will look like this.

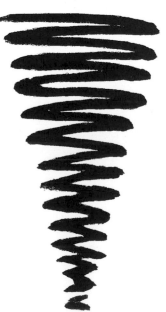

Reflections Blurred by a Light Wind

Without the reflections of the trees below the island, this painting would be static and uninteresting. The water here has a slight ripple and therefore the reflections are slightly blurred. The colors and shapes repeated in the water also help to unite the composition. This was chosen as a demonstration because it shows clearly how to paint a simple reflection.

MATERIALS LIST

OILS
Alizarin Crimson, Burnt Sienna, Cadmium Orange, Cadmium Yellow Light, Cerulean Blue, Cobalt Blue, Payne's Gray, Prussian Blue, Raw Umber, Phthalo Yellow Green, Titanium White, Ultramarine Blue, Viridian, Yellow Ochre

SURFACE
Primed canvas

BRUSHES
Nos. 0, 2, 6, 8 and 10 hog bristle brights, no. 8 hog bristle blender, nos. 0 and 2 sable rounds

OTHER
Palette knife, pencil, turpentine oil medium, mahlstick (optional)

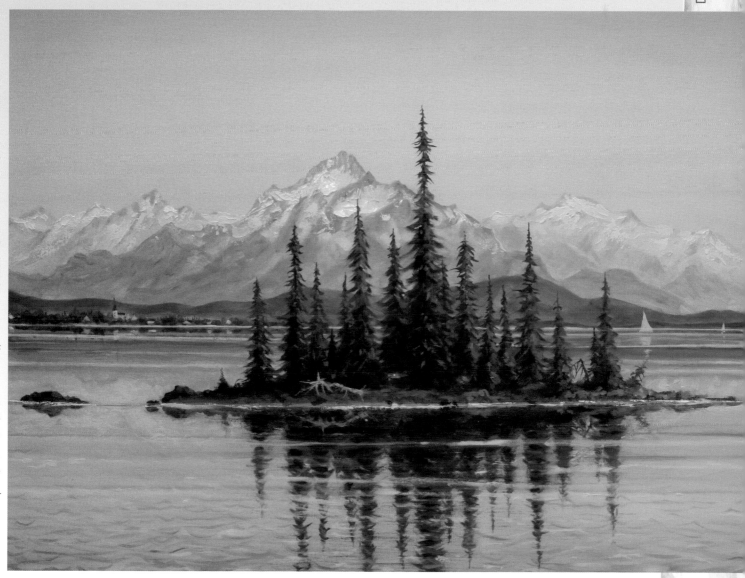

ISLAND LAKE | OIL, 20" × 24" (51CM × 61CM), PRIVATE COLLECTION

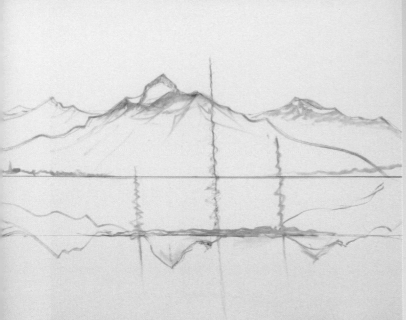

1 SKETCH THE **COMPOSITION**

Sketch the composition on the canvas using pencil, making vertical lines where the main trees will appear. Go over the lines to make them permanent with a no. 0 bright and a mixture of Payne's Gray and Titanium White thinned with turpentine. Let this dry.

2 PAINT THE **SKY**

Mix a fairly large amount of Titanium White with Cadmium Yellow Light and a touch of Burnt Sienna. Use a no. 10 bright to begin painting the sky, starting at the mountains and working your way up about halfway. The strongest color should be next to the mountains and it should fade almost into white as you go higher. Paint from the top of the canvas blending to the center with a mixture of Titanium White, Cobalt Blue and a touch of Prussian Blue while using your no. 10 bright. Carefully repeat this process until the entire sky is blended evenly. Use the same method in reverse for the water.

3 PAINT THE **MOUNTAINS**

Basecoat the mountains with a mixture of Payne's Gray and Titanium White using a no. 8 bright. Use more Titanium White and a touch of Ultramarine Blue to paint the mountains in the background, keeping the details to a minimum. Add more detail to the mountains in the front with the Titanium White and Ultramarine Blue mixture. Use a palette knife and pure Titanium White to create snow on the front mountain.

Create a nice green for the low hills by mixing Payne's Gray and Cadmium Yellow Light. Keep these hills low and soft. Use a no. 2 round to indicate some buildings and trees in the village with Payne's Gray, Cadmium Yellow Light and Raw Umber.

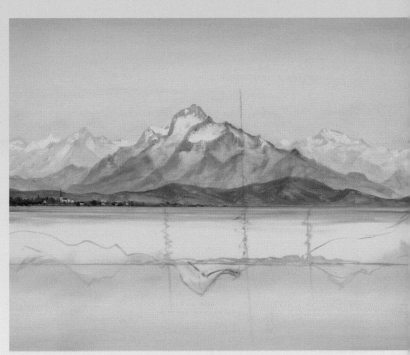

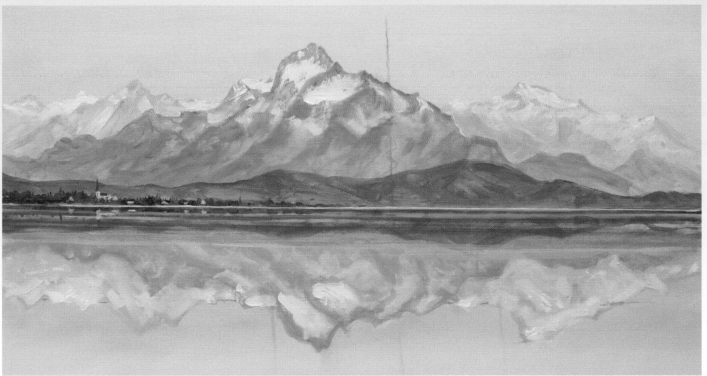

4 ADD THE **MOUNTAINS' REFLECTION**

Using a no. 6 bright and the mixture of Titanium White and Payne's Gray from Step 3, paint the reflection of the mountains and low hills Do not add details at this stage. With a no. 0 round, paint in a thin horizontal line of Titanium White between the land and the lake. Add another line below that using Cerulean Blue mixed with Titanium White. (This line is often seen at the edge of the water between a scene and its reflection.)

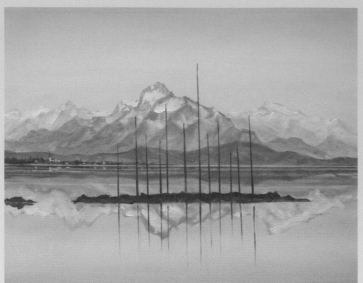

5 PAINT THE **ISLAND**

Mix Cadmium Orange with Raw Umber and lay in the basic shape of the island with a no. 2 bright. Use a mixture of Payne's Gray and Cadmium Yellow Light to create a warm green for the grassy areas on top of the island. With this mixture and a no. 2 round, create the vertical lines that will determine the pine trees. This can easily be done with a mahlstick (see page 132) or by hand.

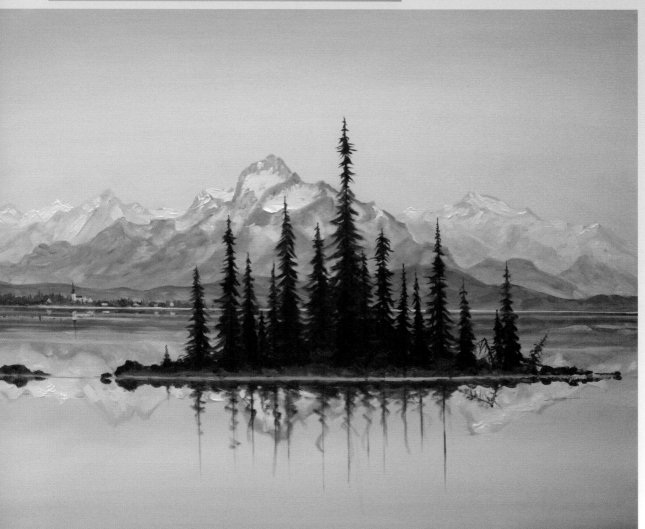

6 PAINT THE **SPRUCE TREES**

Add more Payne's Gray to the mixture of Cadmium Yellow Light and Payne's Gray used in Step 5. Using a no. 2 round, begin on the top of one of the smaller spruce trees, working strokes back and forth on each side until you reach the bottom. Add the branches sparsely in the beginning; you can always add more branches later. Now paint the other trees. Make sure that you make each tree a different size and vary the spacing. Give a little hint of the reflection in the water using the same green.

7 PAINT THE **TREES' REFLECTION**

Paint the spruce trees' reflections using the same color mixture and brush that you used for the trees in Step 6. The vertical lines you placed in Step 1 will come in handy now. Make sure that your reflected trees match the size and shape of the trees they're reflecting. You don't have to add as much detail in the reflections. Use a no. 8 blender to brush horizontal strokes over the reflected spruce trees, keeping light pressure on the brush. Work from right to left and back again a few times until you achieve the effect you want. Use a no. 2 round and some Titanium White and Yellow Ochre to add a dead log to the island.

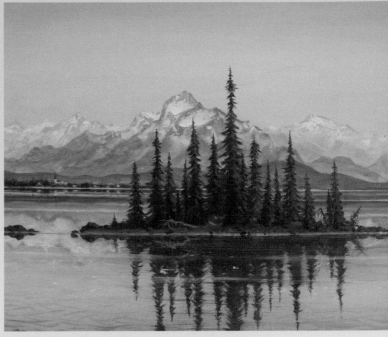

8 ADD **DETAILS**

It's time to work in details of the island, spruce trees and reflections. Mix Prussian Blue and Alizarin Crimson and use a no. 6 bright to blend it into the trees, creating the dark shadows beneath the boughs. Use this mixture on the greens in the reflections. Clean your brush thoroughly.

Use the same brush and Phthalo Yellow Green to create the highlights on the tops of the boughs. Use this here and there in their reflections. Add some horizontal lines of Titanium White and Cerulean Blue in the water.

9 REFINE THE **WATER**

Use a no. 2 round and a mixture of Titanium White, Cobalt Blue and Viridian to create small background wavelets. Use a no. 0 round and pure Titanium White to refine the bigger wavelets in front. Place these strokes at the very bottom of the painting, making them smaller and closer together as they recede.

Painting a Puddle in the Road

After an autumn rain the sun comes out and leaves us with this picturesque scene. The puddle in the road reflects the warm evening sky and the fall trees. Use the reflection in the puddle in the road to balance the light in the sky. This is a good example of achieving balance in a composition. It creates a very appealing landscape.

MATERIALS LIST

OILS

Alizarin Crimson, Burnt Sienna, Cadmium Yellow Light, Cadmium Yellow Medium, Cadmium Orange, Payne's Gray, Titanium White, Prussian Blue, Raw Umber, Ultramarine Blue, Yellow Ochre

SURFACE

Primed canvas

BRUSHES

Nos. 2, 6 and 8 hog bristle brights, no. 6 hog bristle blender, no. 2 sable round

OTHER

Pencil, spray fixative, turpentine oil medium

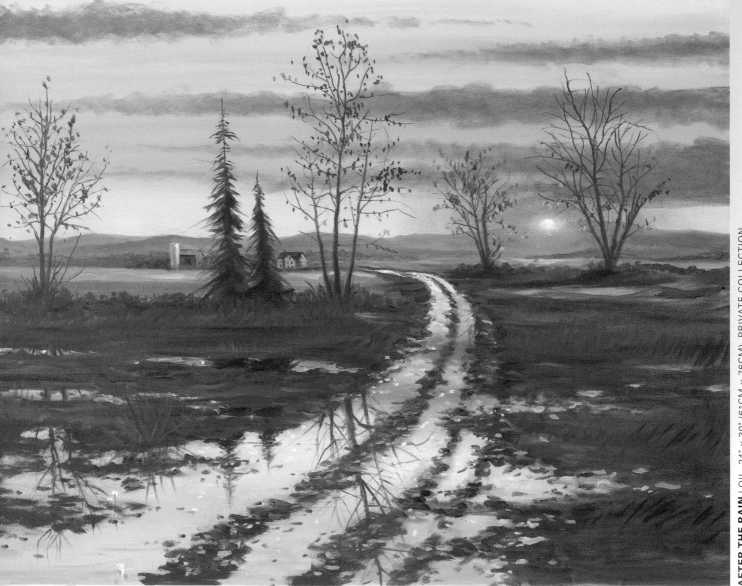

AFTER THE RAIN | OIL, 24" × 30" (61CM × 76CM), PRIVATE COLLECTION

1 LAY IN THE **COMPOSITION**

Draw in the composition with pencil and spray with fixative. Then, using a no. 6 bright, establish the values with washes of Payne's Gray and Titanium White. You will get darker or lighter washes depending on the amount of turpentine you use. Let this dry.

2 PAINT THE **SKY** AND ITS **REFLECTION**

Mix some Cadmium Yellow Light and Titanium White with a touch of Burnt Sienna for the basic color of the sky. Use a no. 8 bright to cover the area of the sky, then add the warmer colors of Cadmium Orange, Cadmium Yellow Medium and Burnt Sienna. Concentrate these colors in the middle of the sky, keeping the lower sky light. Where the sun will appear paint a deeper Cadmium Orange with a no. 2 bright. Repeat the process to paint the sky reflected in the puddle area.

3 ADD **BACKGROUND DETAILS**

Go over the background hills with Payne's Gray, Alizarin Crimson and Titanium White. Using the same mixture with less Titanium White and a touch of Ultramarine Blue, paint the hills and trees. Paint in a barn and house as you wish. Lay in some Cadmium Orange and Titanium White below the trees. Next add Burnt Sienna to this mixture and paint another layer of color below the last.

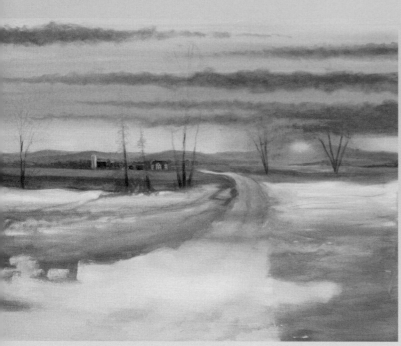

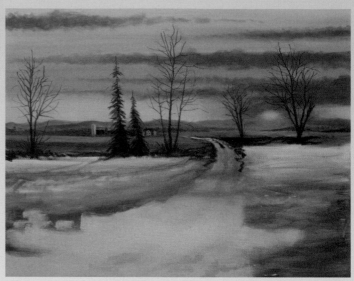

4 PAINT THE **CLOUDS**

Using a no. 6 bright and Alizarin Crimson, Payne's Gray and a little Titanium White, paint the clouds with horizontal strokes. Take care to leave some of the warm sky. Now, place some Titanium White in the center where the sun would be. You can soften it by using your finger and rubbing the area in a circular motion.

5 PAINT THE **TREES**

You should still be able to see the placement of the trees from your original sketch. Paint the deciduous trees using a no. 2 round and some Raw Umber. Thin your paint with turpentine to make it flow more easily. Paint the spruce trees using Prussian Blue and Raw Umber.

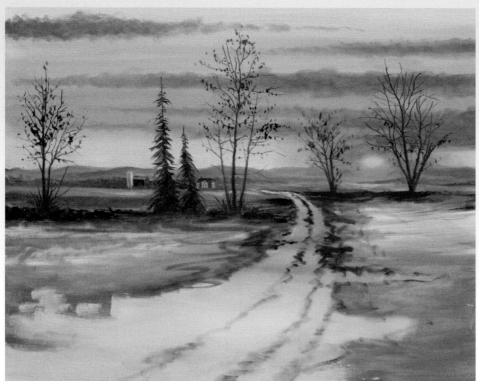

6 ADD THE **FALL LEAVES**

Mix some Cadmium Orange and a touch of Burnt Sienna and create leaves with a no. 2 bright using small strokes. Don't add too many leaves since they would restrict the view of the sky, which is an important element in this painting.

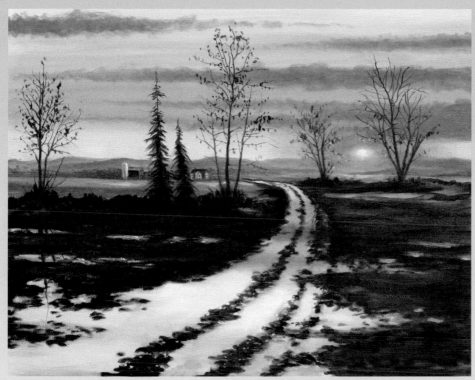

DETAIL OF REFLECTIONS

This close-up shows you how your reflections should look. Notice how the track in the road breaks up the reflection. Also note the white spots, which were intentionally applied. They add some sparkle to the water and can be achieved by simply dotting the water with pure Titanium White.

7 ADD THE **ROAD**

Paint the areas on each side of the road using a mixture of Burnt Sienna and Raw Umber and a no. 6 bright. Make the road darker as you work toward the foreground. To achieve this, add a little Alizarin Crimson to the Burnt Sienna and Raw Umber mixture. Leave some open spaces for puddles under the trees on the left. Add some tiny reflections in these puddles for further interest.

8 PAINT THE **TREES' REFLECTIONS**

Paint the reflections of the trees with the same colors and brushes that you used for the actual trees in Step 5. Make sure that the reflections come directly toward the viewer. Soften the reflections by lightly pulling a clean, dry no. 6 blender horizontally over them. Add interest to the foreground grasses and brush with touches of Yellow Ochre, Cadmium Orange and Burnt Sienna.

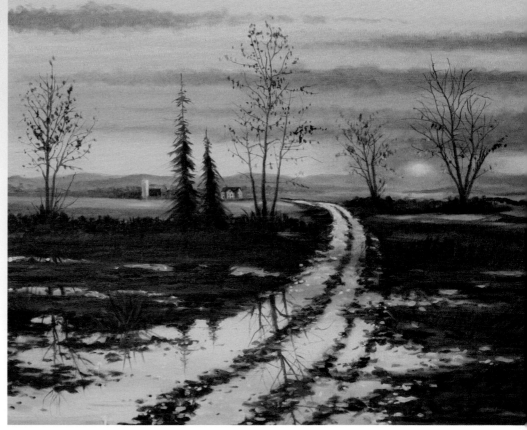

Winter Pond

The blue shadows on the snow and the perfect reflections cast on the pond make this an ideal subject to paint.

MATERIALS LIST

OILS
Alizarin Crimson, Burnt Sienna, Cadmium Orange, Cadmium Yellow Light, Cerulean Blue, Cobalt Blue, Prussian Blue, Raw Umber, Titanium White

SURFACE
Primed canvas

BRUSHES
Nos. 2 and 6 hog bristle brights, no. 2 sable round

OTHER
Pencil, spray fixative, turpentine oil medium

WINTER POND | OIL, 20" × 24" (51CM × 61CM), PRIVATE COLLECTION

1 SKETCH THE **COMPOSITION**

Draw a basic sketch on your canvas using pencil and then spray with fixative to make sure no graphite mixes with the paint. Let the fixative dry.

USING SPRAY FIXATIVE

When you use pencil to sketch in a scene in oil or acrylic you should use fixative. Otherwise, the graphite in the pencil will mix with the paint. If you were painting a light blue sky, the graphite would make the paint look gray, for example. The only time you should not use fixative is when you're painting in watercolor.

2 PAINT THE **SKY** AND **SNOW**

With a no. 6 bright, paint a warm sky using a mixture of Titanium White with a touch of Cadmium Yellow Light and Burnt Sienna, blending colors and getting darker as you proceed toward the horizon. Repeat this procedure in reverse as you paint the water, but add some Cobalt Blue at the bottom of the picture. Paint the snow and its reflection with Titanium White using a no. 2 bright. Paint blue shadows over the white with Cobalt Blue and a touch of Cerulean Blue. Use a much darker version of the colors from above to paint the reflection of the snow. Create the dark area at the edge of the water with a mixture of Prussian Blue and Raw Umber. With a no. 2 bright, paint in the posts, the rock and lumps of dirt using a mixture of Cobalt Blue and Raw Umber.

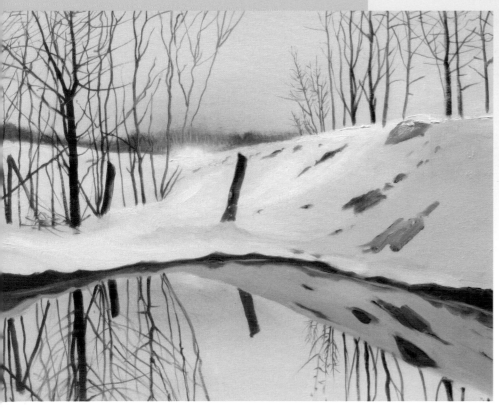

3 ADD THE **TREES** AND THEIR **REFLECTIONS**

Using a mixture of Burnt Sienna and Cadmium Orange, paint the woods on the horizon using a no. 2 round. Use your index finger and some straight Titanium White to place the sun and blend the edge. Now mix up some Cadmium Orange and Raw Umber for the trees. Use a no. 2 round for the tree branches. Mix Raw Umber with Alizarin Crimson and paint the shadows on the big trees. Use straight Cadmium Orange for the highlights. Repeat this on the trees reflected in the water. If you want to add other details, do so at this time.

STRUCTURES OVER WATER

We often encounter structures that are not on land next to water, but are built over water, such as bridges and docks. The challenge for the painter is that the structure is suspended and therefore the water below it will reflect differently than if the structure was on land.

You can face this challenge by imagining that the water underneath the structure is a mirror. You have already learned that water acts like a mirror. The water under the structure would then reflect the underside of the structure. This is very important. Many amateur painters forget this fact and paint the structure itself in reverse. Remember that when you paint a structure over water, you'll be painting the bottom of the structure as it's reflected in the water.

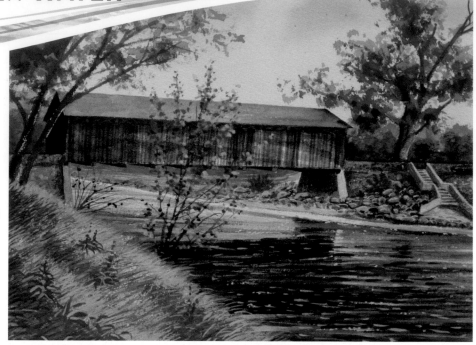

ADA BRIDGE | WATERCOLOR, 13½" × 18" (34CM × 46CM), PRIVATE COLLECTION

COVERED BRIDGE

This red covered bridge over the water is a great focal point. In this painting the underside of the bridge is reflected in the water.

A BRIDGE SEEN FROM ABOVE

From a position that looks down on a bridge, you'll observe that you are looking at the top of the bridge and the road that goes over it. Notice that you can also see the underside of the bridge reflected in the river—not the bridge in reverse.

OBSERVATION IS ESSENTIAL

Look closely at the man sitting on the edge of the dock, fishing. Because the dock is obstructing your view, you cannot see the fisherman's feet. However, his feet are visible in the water's reflection. You can also see the underside of the dock in the water's reflection.

ARCHED BRIDGES

This unusual bridge is another example of structures over water being reflected. The two arched supports form almost perfect ovals with their reflections below. After painting the bridge with the arches, I painted the reflection of its underside in the water. Then I made several long, vertical lines in the water to break up the reflection and make the water believable. I created the light, horizontal lines in the water by scratching over the dried watercolor with a craft knife.

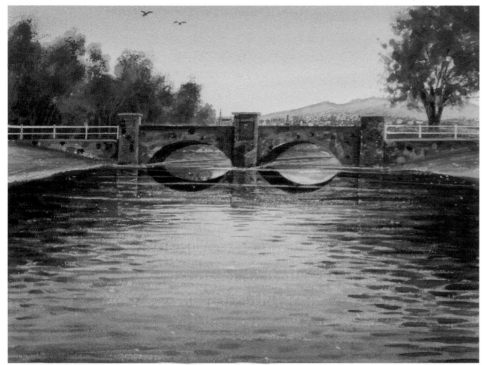

MIDDAY BRIDGE | WATERCOLOR, 13½" × 18" (34CM × 46CM), PRIVATE COLLECTION

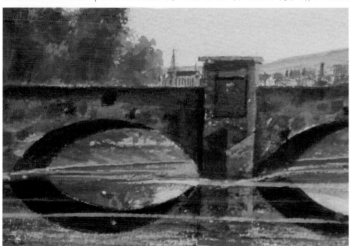

CLOSE-UP UNDER THE BRIDGE

Under the bridge we can see the trees and sky reflected behind the bridge.

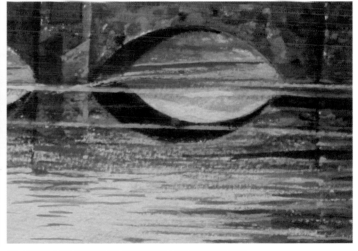

CLOSE-UP OF THE BRIDGE SUPPORTS

The bridge supports are reflected in the water, but are slightly broken up due to the ripples in the water.

BOATS ON WATER

Even though this book is about painting water, we can't avoid talking about boats. No matter what kind, boats are a favorite subject for painters. Boats, especially sailboats, are a favorite addition to any idyllic seascape. To make them look "real," whether they're floating or moored on the water, requires two factors: knowledge and understanding. You need to *know* what various boats look like and *understand* how the water behaves around a boat under different conditions.

We've all seen tall ships or navy cruisers and the huge bow waves they create that spray up and engulf half of the ship. On the other hand, while sailing, I have been passed by oceangoing freighters within thirty feet and they hardly made a ripple. This is due to their special bow and hull design. I have also sailed near a jet-powered catamaran tourist boat whose giant wake nearly shattered everything on my tiny, thirty-four-foot yacht.

Your first consideration in painting a boat on the water should be whether the water is still or has waves. On totally still water any boat will reflect a nearly perfect image of itself. When the boat moves slowly forward, the water near the edge of the boat will rise up slightly, moving away from the boat and causing small ripples to form. When the boat speeds up the ripples will become higher. Behind the boat a trail or *wake* is formed. The size of the wave is also a consideration. This chapter is focused on still or slightly rippled water. Chapter 5 will discuss higher waves.

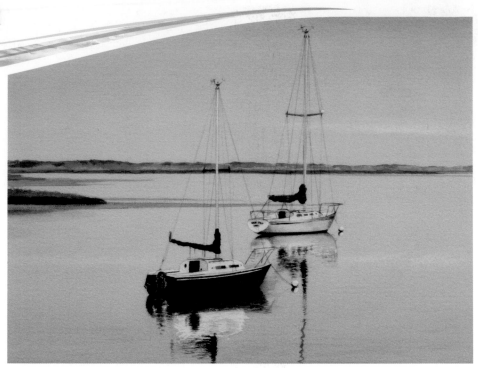

MOORED SAILBOATS | WATERCOLOR, 20" × 24" (51CM × 61CM), COLLECTION OF MR. AND MRS. RICHARD CARNES

CLEAR REFLECTIONS FROM STILL WATER

These sailboats at low tide are *moored*, or tied to a buoy. Since no ships are passing and waterway winds have not built up, the reflections are almost perfect except for a few little ripples.

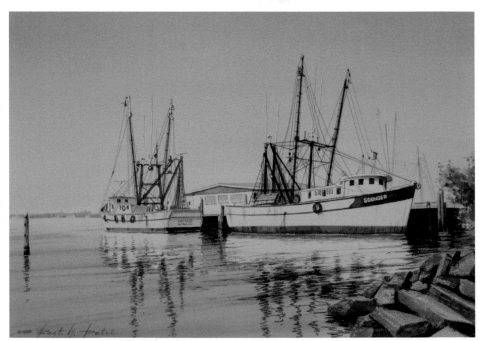

SHRIMP BOATS | WATERCOLOR, 15½" × 22" (39CM × 56CM), PRIVATE COLLECTION

CHOPPY REFLECTIONS

The shrimp boats are docked at high tide. Passing boats in the area created a little wave action, chopping up these boats' reflections. Use the horizontal stroke method and the zigzag stroke method (see page 34) to achieve this effect.

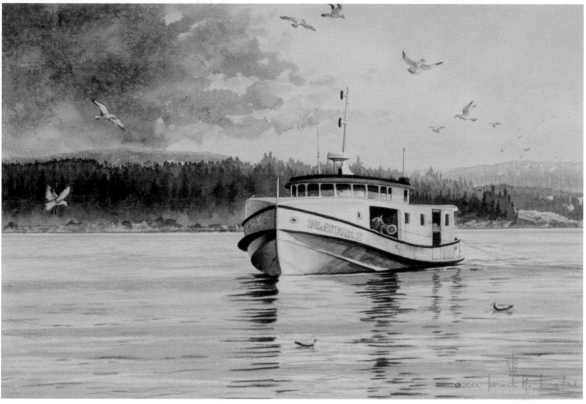

SLOW-MOVING BOAT

The fishing boat in Lake Huron's North Channel is going at a slow pace. There is not much wind and therefore the reflection is only a little broken-up. I used the zigzag method on the dark reflections on the right, but used a modified version on the reflection of the bow by dragging the brush from right to left. I added interest to the painting by adding the seagulls that always hang around fishing boats waiting for a meal.

FAST-MOVING SCHOONER

This three-masted schooner with all sails up is going at a good clip. The sails are filled, and the boat is *heeling*, or leaning to one side, yet the water is only slightly choppy. This is because of the wind's direction coming off the land (or *lee side*,) which has neither the time nor the distance to build any waves. Accordingly, there is no reflection of the boat on the water—only a shadow from the boat and the white wake.

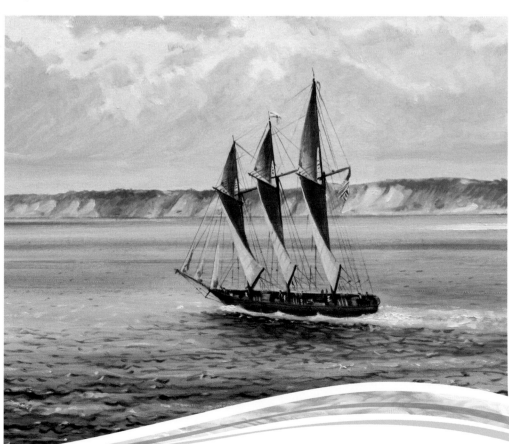

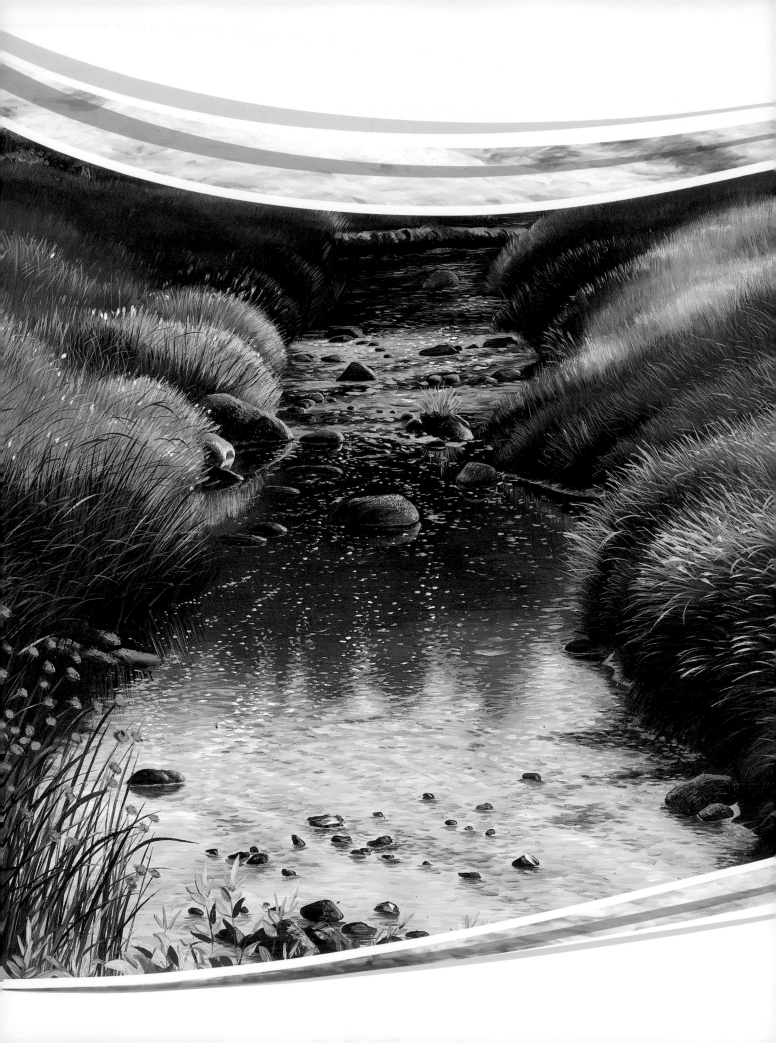

BROOKS, STREAMS AND RIVERS

Brooks, streams and rivers all represent a natural flow of water in a well-defined channel. They serve as water sources for people, animals and plants, and as a means of transportation.

Painting rivers and streams requires us to explore the various moving waters in more detail. Some rivers move very slowly and we can see the reflections of the trees and whatever else surrounds them on the banks. There may be hardly a ripple on the surface. If you've ever paddled a canoe down a river, you know what I am speaking of. It's a profoundly spiritual experience.

This is in contrast to the exhilarating experience of paddling through rushing white water and swift currents. As observing artists, these experiences come to mind whenever you attempt to paint a river. The experience of being on a river is worth conjuring up as it will help you render the same tranquility of a quiet river or the excitement of white water.

Rivers and streams can be surrounded by just about anything—rocks, steep cliffs, lush grasses, tall trees, quaint little villages or giant cities. The wildlife around them is also infinite and can add to the beauty of the scene. By adding a deer drinking at the edge of a river, or ducks paddling in a slow-moving stream, you can make your painting even more interesting.

MEADOW BROOK | OIL, 24" × 30" (61CM × 76CM), COLLECTION OF CHARLES SILKY

RIVERS AND PERSPECTIVE

Perspective is an important part of painting any landscape or seascape. When painting rivers, brooks or streams, it's crucial that you take perspective into account, especially your vantage point. The angle at which you view the river changes what you see. We all understand that things that are closer appear larger and things that are farther away appear smaller. If you're viewing the river at a low vantage point, you'll see that the closest part of the river is much larger but the river quickly becomes smaller in the distance. If you're viewing the river from a high vantage point (looking from above) you can see farther and therefore see more of the river as it slowly gets smaller and moves into the distance.

The paintings on this page are of the same river, but because of the difference in vantage point, they look very different.

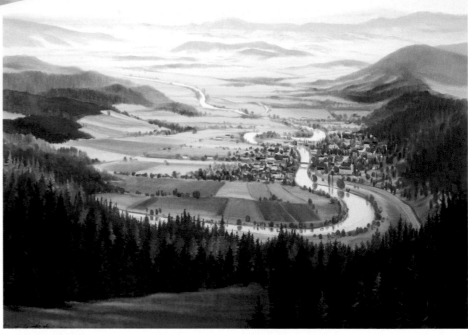

LAZY RIVER | OIL, 20" × 24" (51CM × 61CM), PRIVATE COLLECTION

HIGH VANTAGE POINT
Looking down on the river from a mountaintop allows the viewer to see the river slowly becoming smaller as it meanders into the distance.

LOW VANTAGE POINT
If you look at the river from its bank, the part closest to you is wide—wide enough to show reflections. As the river turns and moves away from you, you'll see less of the river. As the river moves to the left behind the bank, it becomes a narrow line and finally disappears out of the picture.

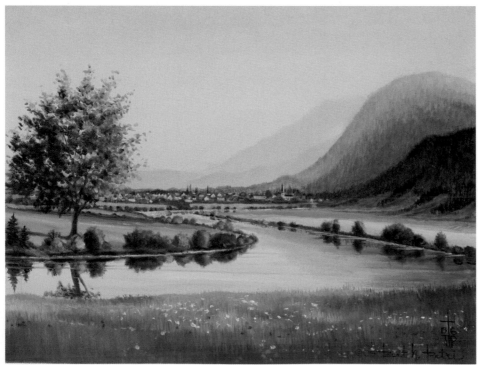

BEAUTIFUL VALLEY | OIL, 22" × 28" (56CM × 71CM), COLLECTION OF JANICE MJOVIG

Fall Brook

While we aren't positioned very high relative to the landscape, we are very close to the water. If we were to make a cross section from the side we would see that we look at the water at an angle of about 45 degrees close up, and about 20 degrees relative to the far side of the stream. Only the tallest trees reflect in the water.

MATERIALS LIST

WATERCOLORS
Alizarin Crimson, Burnt Sienna, Cadmium Orange, Cadmium Yellow Light, Chinese White, Cobalt Blue, Ivory Black, Prussian Blue, Phthalo Yellow Green, Raw Umber, Viridian, Yellow Ochre

SURFACE
Cold-pressed watercolor paper

BRUSHES
1½-inch (38mm) flat house-painting brush, nos. 2, 4 and 8 sable rounds

OTHER
Craft knife, pencil

DEMONSTRATION | WATERCOLOR

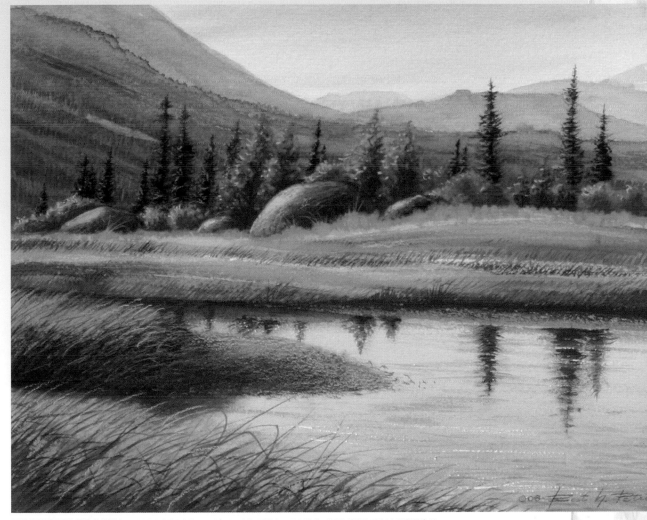

MOUNTAIN BROOK | WATERCOLOR, 16" × 20" (41CM × 51CM), PRIVATE COLLECTION

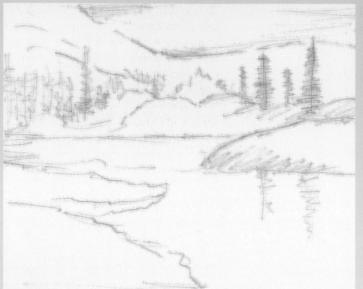

1 SKETCH THE **LANDSCAPE**

Draw the composition on watercolor paper with a pencil. Since this is a watercolor painting, draw your lines very lightly so they don't show in the finished picture. You can erase any remaining pencil lines later.

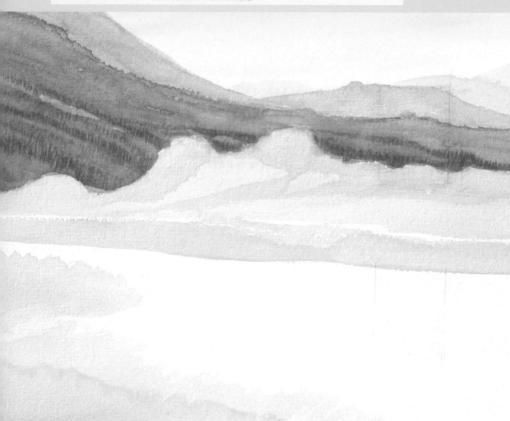

2 ADD **WARM COLORS**

The overall painting has a very warm tone. The sky and its reflection in the stream are the only cool colors in the painting.

On your palette, mix Cobalt Blue with a touch of Prussian Blue. Wet the entire sky area with clean water using your 1½-inch (38mm) house-painting brush. Dip the brush into the blue mixture and wipe it horizontally across the sky starting at the top, then tilt the painting up about 45 degrees to let the wet paint blend. Let this dry.

Now apply a light wash of Yellow Ochre over the entire landscape (except where the stream will be) using a no. 8 round. Mix Cobalt Blue and a very small touch of Alizarin Crimson and paint the far mountains. Keep adding just a little Alizarin Crimson to each mountain range as you come closer to the foreground.

When you come to the wooded hills, mix Yellow Ochre with a small amount of Prussian Blue. Use this mixture to create the wooded hills in front of the mountains. Use a stronger mixture with less water to create the small trees on the hills. Simply make small, vertical lines with the no. 2 round and let dry.

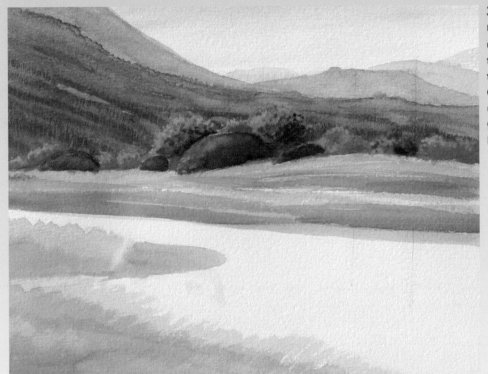

3 COMPLETE THE **WOODS**

Using a no. 2 or 4 round, paint over the woods using very short strokes to give them the texture of fir trees. Add patches of different trees with Alizarin Crimson, Yellow Ochre and Cadmium Orange. Lay in the nearby aspen using Cadmium Yellow Light, Cadmium Orange and a touch of Ivory Black. Paint the boulders with Burnt Sienna and Ivory Black.

4 PAINT THE **GRASS**

Add Chinese White to Cadmium Orange and apply this mixture with a no. 2 round to give the aspens their final, pointed shape. Use Yellow Ochre, Cadmium Yellow Light, and Cadmium Orange with just a small touch of Ivory Black to underpaint the grass. Use Yellow Ochre and Burnt Sienna to refine the strip of land in the stream.

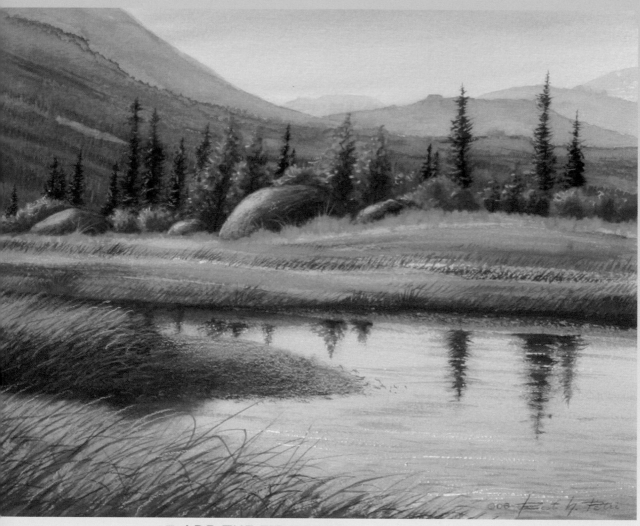

5 ADD THE **FIR TREES**

Begin to paint the fir trees using a mixture of Viridian, Raw Umber and some Ivory Black with a no. 2 round. Use the same mixture and brush to make the reflections of the fir trees in the water with the horizontal stroke method (see page 34). Clean your brush thoroughly. Create a mixture of Chinese White and Cadmium Yellow Light and use your no. 2 round to paint highlights on the orange deciduous trees. Add a touch of Phthalo Yellow Green to Chinese White and, using the same brush, create highlights on the green trees. Add highlights to the boulders using Chinese White and a small touch of Raw Umber. Now you can work on the tall grasses using a mixture of Yellow Ochre, Cadmium Orange, Alizarin Crimson and a touch of Viridian with a no. 2 round. Let the painting dry thoroughly.

Using a craft knife, scrape some horizontal lines across the water and the reflections of the trees. This will give the water texture. Using Raw Umber and a no. 4 round, make a soft, dark line at the edge of the water where the grass hangs over and creates a shadow and its reflection.

Conveying Water Temperature

This little brook is located on land we once owned. It often dried up in the summer but in late winter, when the snow began to melt, this little brook would swell up and with much energy would fill up the lower valley.

Painting a winter brook with its cold waters is a challenge: How do you convince the viewer that the water is cold? One way is to create a strong contrast between the snow and the water. Also, by using cool blues in both the water and the snow's shadows, you can allude to the cool temperature.

MATERIALS LIST

ACRYLICS
Alizarin Crimson, Burnt Sienna, Cadmium Orange, Cerulean Blue, Cobalt Blue, Ivory Black, Payne's Gray, Prussian Blue, Raw Umber, Titanium White, Yellow Ochre

SURFACE
Primed canvas

BRUSHES
Nos. 2, 4 and 8 hog bristle brights, no. 2 sable round

OTHER
Toothpick

DEMONSTRATION | ACRYLIC

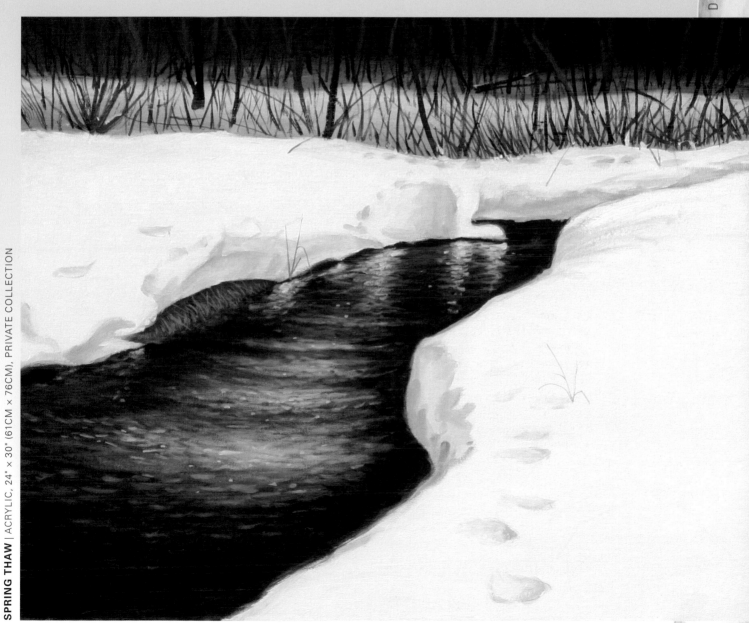

SPRING THAW | ACRYLIC, 24" × 30" (61CM × 76CM), PRIVATE COLLECTION

1 SKETCH THE **COMPOSITION**

Start by drawing the composition with a no. 2 bright and a mixture of Payne's Gray and Titanium White. By filling in the area of the brook with this dark gray, you'll get a better feel for the entire scene.

2 BLOCK IN THE **BLUE AREAS**

If you look carefully at this scene, you'll find three different blues: Cerulean Blue, Cobalt Blue and Prussian Blue. Use Titanium White with Cerulean Blue and a no. 8 bright to paint the edge of the woods where the underbrush begins. Add Cobalt Blue to the bottom of this area and blend. For the very dark area of the underbrush, start with Cobalt Blue, adding Prussian Blue as you work up and blend. Blending the sections will prevent these areas from appearing flat. Paint the brook with a no. 8 bright and a mixture of Prussian Blue and Alizarin Crimson.

3 PAINT THE **WATER**

With a no. 4 bright and a mixture of Titanium White and Cerulean Blue, start at the top of the brook using horizontal brushstrokes. As you work down toward the foreground use more Cerulean Blue and less Titanium White. Use this mixture and a no. 2 round to paint the footprints along the snow-covered river banks. Add sparkle to the water with dots of straight Titanium White using a toothpick, but don't overdo it. Add some Burnt Sienna to the old grass on the left side of the brook.

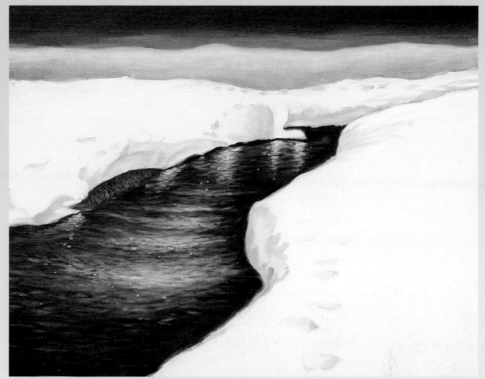

4 PAINT THE **WOODS**

Use a variety of dark colors such as Raw Umber, Ivory Black, Alizarin Crimson, Cadmium Orange and Yellow Ochre to paint the dark trees of the background woods and the closer underbrush. Make sure your trees and broken branches aren't too alike or bent in the same direction. Using a no. 2 round and a mixture of Titanium White and Payne's Gray, put in a few highlights and snow clumps on the trees and bushes. Use a mixture of Yellow Ochre, Cadmium Orange and Titanium White to highlight some blades of grass.

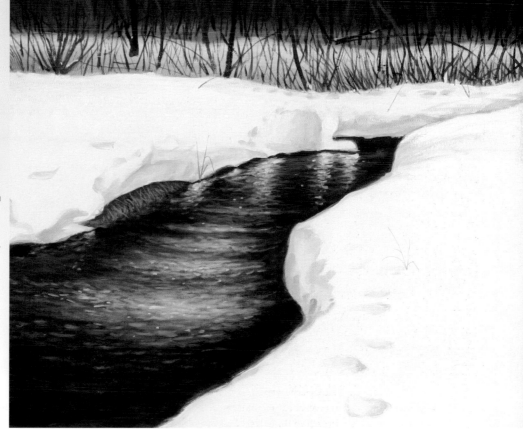

Slow-Moving River

The White River is gentle and moves slowly through the scenery. The outcroppings of the terrain on each side, the rocks and other obstructions are sources of small ripples.

The observer of this river will know immediately that it's moving slowly. You can emphasize this in your painting by adding horizontal lines and blurred reflections. The water's edge, with its slow gradation, gives more clues to the speed of the river. If the water were moving quickly, the edges of the river would be more eroded. As an artist, these are details to be aware of to indicate a slow-moving river.

MATERIALS LIST

OILS
Alizarin Crimson, Burnt Sienna, Cadmium Orange, Cadmium Yellow Light, Cobalt Blue, Mars Black, Payne's Gray, Prussian Blue, Raw Umber, Titanium White, Viridian, Yellow Ochre

SURFACE
Primed canvas

BRUSHES
Nos. 2, 4 and 10 hog bristle brights, no. 6 hog bristle blender, nos. 1 and 2 sable rounds

OTHER
Liquin, pencil, turpentine oil medium

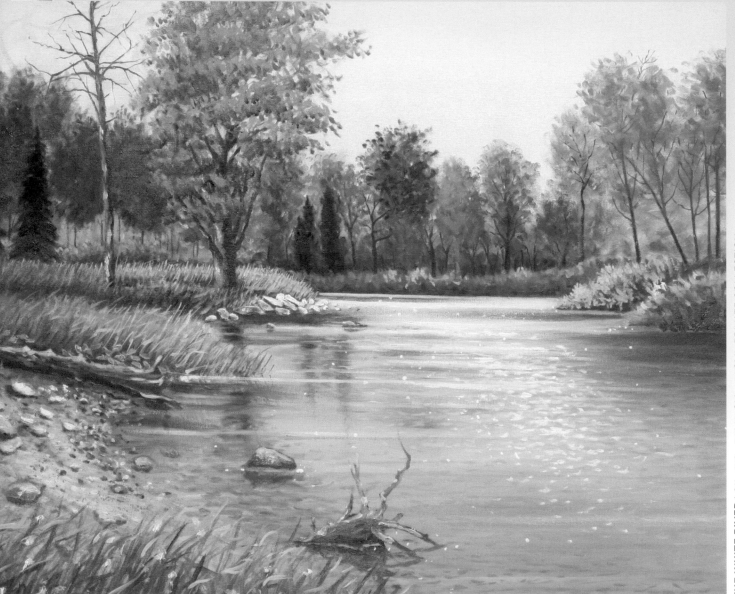

THE WHITE RIVER | OIL, 24" × 30" (61CM × 76CM), PRIVATE COLLECTION

1 SKETCH THE **COMPOSITION**

Begin the painting by roughing in the scene with a pencil. Next, create a mixture of Payne's Gray and Titanium White and apply it to the entire painting with a no. 4 bright. Use a medium consisting of Liquin and turpentine to facilitate the workability of the paint and to speed up the drying time. Let this dry completely.

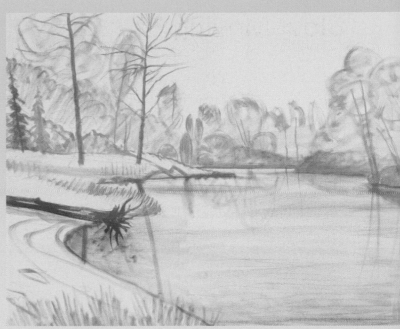

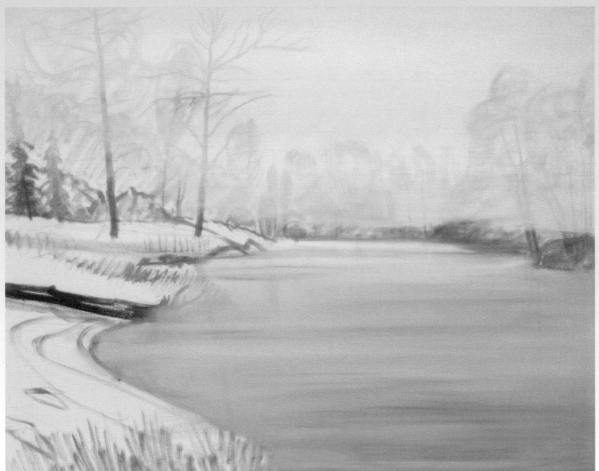

2 PAINT THE **WATER** AND **SKY**

Paint the sky with a no. 10 bright and a mixture of Titanium White, Cobalt Blue and Prussian Blue. Start at the horizon with straight Titanium White and keep adding the blue mixture as you work toward the top of the sky. Make sure the paint is thin enough so you can still see your pencil drawing. When you're satisfied with its color and value, blend the sky's colors with a no. 6 blender. Use this process to paint the water, except begin adding the blue mixture as you work downward. The deepest blue should be at the bottom of the canvas.

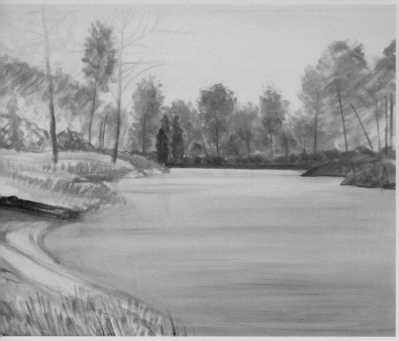

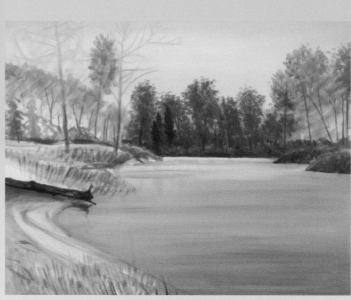

3 PAINT THE **TREES, GRASS** AND **BEACH**

When painting the trees it's best to start at the trees farthest away and work forward. Paint the shapes of the back trees loosely with a mixture of Cadmium Yellow Light and some Mars Black and a no. 2 bright. Paint the trees on either side using the same mixture but adding a touch of Raw Umber. Don't paint the large tree on the left foreground yet. Indicate the beach on the left with Yellow Ochre that's been thinned with turpentine and a no. 4 bright.

4 DEFINE THE **BACKGROUND TREES**

Now, with the same brushes and mixtures used in Step 3, start refining the background trees. Use Alizarin Crimson, Viridian and Mars Black to make different trees and to add some shadows with a no. 4 bright. Use more Mars Black for the fir trees. As you paint the trees, use the various greens you've mixed to begin to paint the grass.

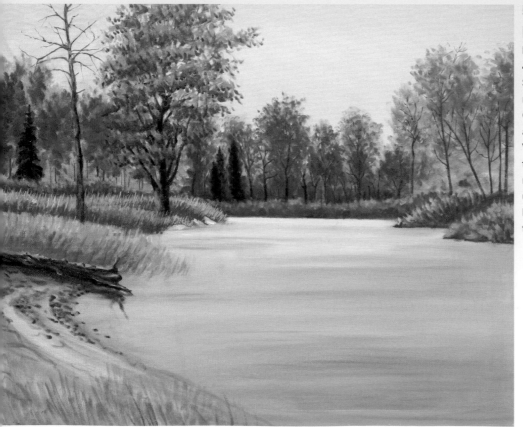

5 REFINE THE TWO **LARGER TREES**

Paint the dead tree on the left using a no. 4 bright and Raw Umber mixed with Burnt Sienna. Paint the trunk of the large tree to the right of it with the same brush and Payne's Gray. Add bluish-green leaves to this tree with a no. 4 bright and a mixture of Titanium White, Viridian and a small touch of Raw Umber. Paint the orange tree at the back of the river with a mixture of Cadmium Orange and Burnt Sienna using a no. 4 bright. Use the same mixture and brush to put some orange into the bushes to the right.

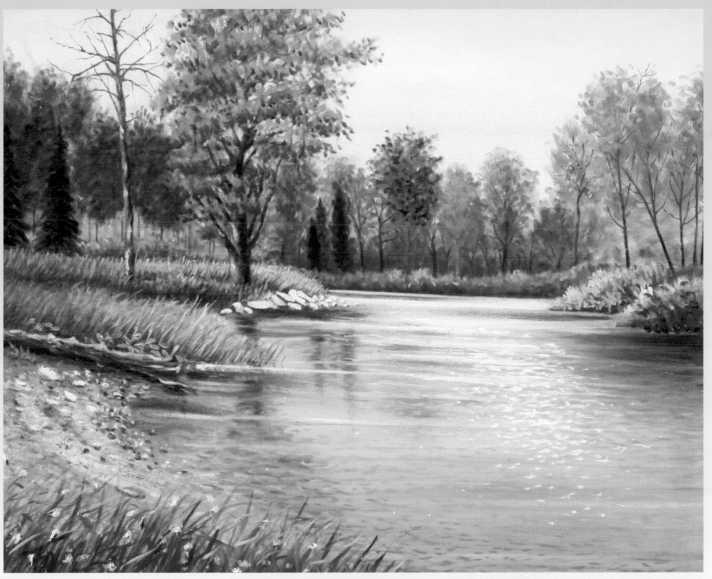

6 ADD **REFLECTIONS** TO THE **WATER**

Carry some of the colors from the trees down into the water to add reflections. With a no. 4 bright, make a few streaks of orange in the water below the orange tree. Using a mixture of Cadmium Yellow Light and Mars Black and the horizontal stroke method (see page 34), paint the reflection of the pine trees and the bushes on the right. Using this same color and brush begin to put more green into the grasses at the left. Add horizontal strokes of Titanium White across the water's surface. Depict the water's sparkle by adding dots of Titanium White with a no. 2 round.

Add highlights to the top of the log with Titanium White and a small amount of Yellow Ochre with a no. 2 round. Use the same brush and mixture to add some spots to the sand for texture. Take the no. 2 round loaded with Burnt Sienna and add some shadows under some of your dots to make them appear like stones.

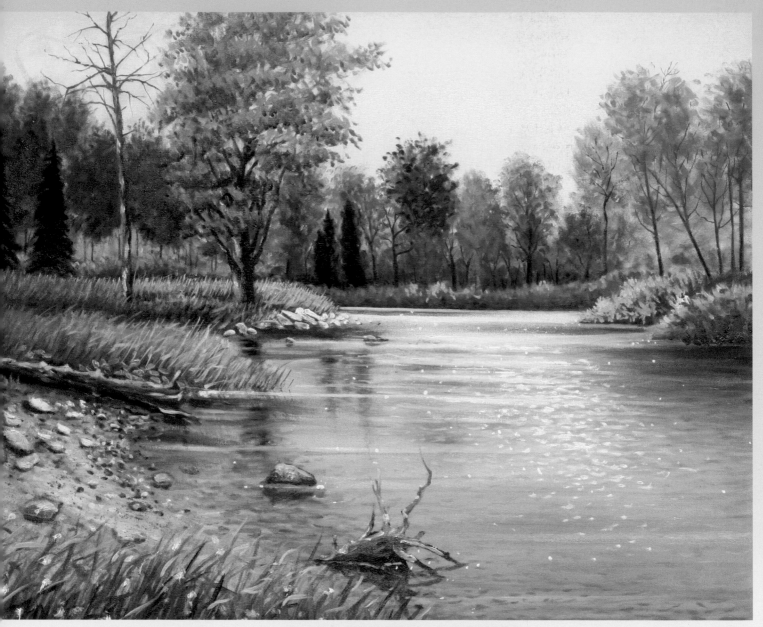

7 ADD THE **FINAL TOUCHES**

Paint in the big rock and the old tree stump on the bottom of the picture with Raw Umber, and small amounts of Alizarin Crimson and Prussian Blue, using a no. 2 round and no. 2 bright. Use this mixture to paint the rock, tree stump and their reflections. Add a fine, white line between the stump and its reflection and the rock and its reflection with Titanium White and a no. 1 round.

Use a mixture of Titanium White, Cadmium Yellow Light and some Cadmium Orange and a no. 1 round to add some light and warmth to the foreground grass in the middle left. Add some hints of small flowers with Titanium White and Cadmium Yellow Light.

Fast-Moving Brook

A small brook seeks its bigger relatives. It has miles to go, and on this journey it will encounter various terrain. It tumbles over the rocks and fallen trees on its way.

The artist who wants to paint a fast-moving brook must carefully observe the many twists and turns the water makes as it maneuvers among obstacles.

The water will at times become "white" water as it's churned up and around. As the water moves around each rock it leaves a trail of white. Use very energetic brushstrokes with angled and curved lines that follow the movement of the water.

MATERIALS LIST

OILS
Alizarin Crimson, Mars Black, Cadmium Orange, Cadmium Yellow Light, Cadmium Yellow Medium, Cobalt Blue, Prussian Blue, Payne's Gray, Raw Umber, Titanium White, Viridian

SURFACE
Primed canvas

BRUSHES
Nos. 2, 4, 8 and 10 hog bristle brights, no. 6 hog bristle blender, no. 2 sable round

OTHER
Pencil, spray fixative, turpentine oil medium

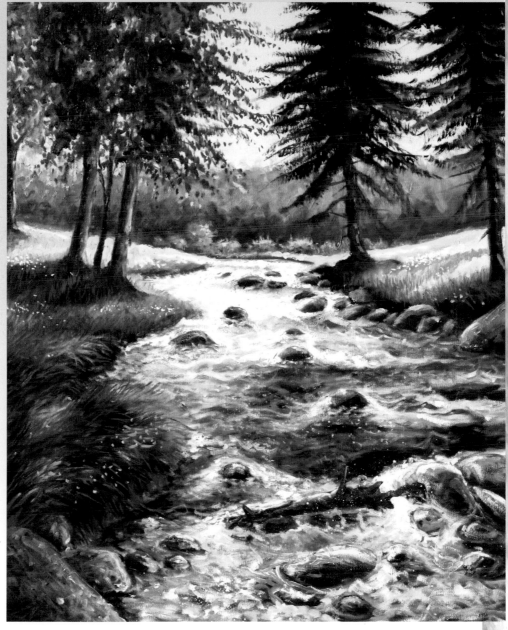

HEADWATERS | OIL, 24" × 30" (61CM × 76CM), PRIVATE COLLECTION

DEMONSTRATION | OIL

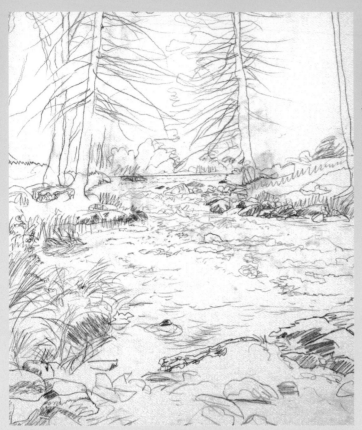

1 SKETCH THE **COMPOSITION**

Begin by sketching the scene with pencil. Spray the pencil lines with fixative so the graphite doesn't mix with your paints.

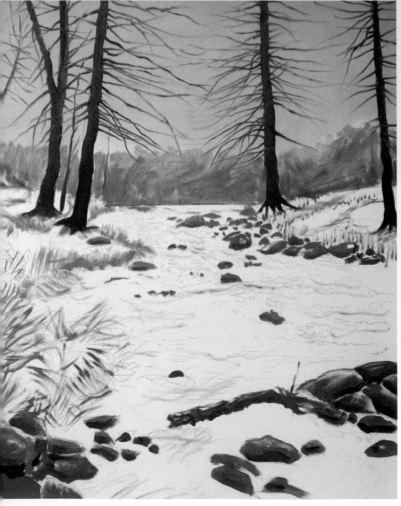

2 PAINT THE **SKY, TREES** AND **ROCKS**

Begin painting the sky with a layer of Titanium White using a no. 8 or 10 bright. As you work up from the background trees, add Cobalt Blue mixed with a small amount of Prussian Blue and blend this into the Titanium White with a no. 6 blender. Blend the colors back and forth several times, wiping the blender clean after each pass. Make sure these background trees are lighter than those in the foreground. Paint the trees and rocks with a no. 2 bright and a mixture of Raw Umber, Payne's Gray and Titanium White. Paint the fallen tree trunk using Raw Umber and Cadmium Orange.

3 ADD THE **GRASSES** AND **WATER**

Mix a generous batch of medium green using Cadmium Yellow Light, Viridian and Raw Umber. Create a batch of lighter green by adding some Titanium White. Use these mixtures to paint the foliage in the background trees and all the grassy areas with nos. 2 and 4 brights. Use a no. 2 round to add more detail to the grasses.

To paint the water, make a thin glaze with Titanium White, Cobalt Blue and a lot of turpentine oil medium. Paint over the entire water area with this glaze using a no. 4 bright. Make sure that the rocks and other details are still visible through the glaze. Use more Cobalt Blue in the glaze to begin to establish the darks in the water.

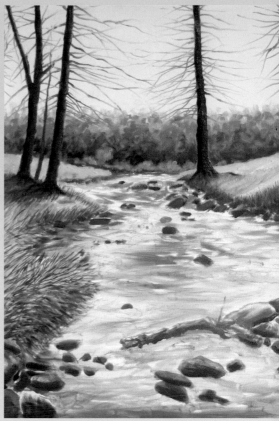

4 REFINE THE **PINE TREES** AND **WATER**

What you've done so far is establish the under-painting. Now you will begin the fun part—the actual painting of the scene. Start by painting the woods in the back, the low trees and the bushes at the edge of the woods, and the dark at the bottom of the trees in the back. Use the same green mixtures as in Steps 2 and 3, but add some Raw Umber and Cadmium Orange. With a no. 2 round paint the branches on the left side of the trees. Use a no. 6 blender to paint the boughs on the fir trees. With a deep yellow or orange (use either Cadmium Yellow Light or Cadmium Orange), warm up the grass. Add Mars Black to the green to paint the dark shadows and edges of the grass. Now begin to paint the water using short, horizontal strokes with a no. 4 bright and a mixture of Titanium White, Cobalt Blue and Prussian Blue, making sure to leave some areas white.

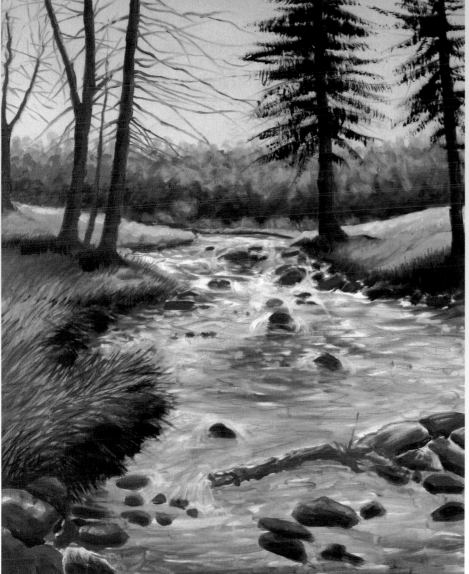

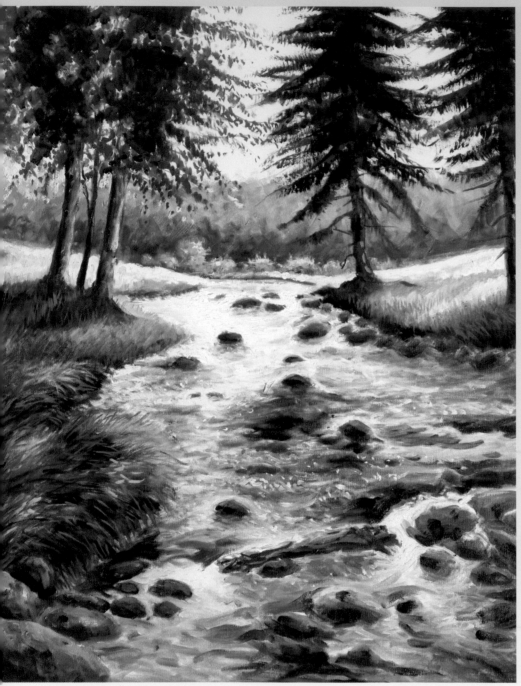

DETAIL OF FOREGROUND

The water behind the trunk is dark. As the water is held back by the trunk and rocks it begins to swirl and causes white water to form. You create this by using pure Titanium White and working in swirls. The rocks are wet and also have Titanium White highlights on them.

5 FINISH THE **TREES**

In this step you'll work almost exclusively with greens. Using a very light green, made from Cadmium Yellow Light and tiny touches of Mars Black and Cadmium Orange, put in the lights at the top of the forest, the bushes and the meadows with a no. 4 bright. Use this mixture to add some highlights to the grass under the trees. Paint the foliage on the trees on the left with a very dark green made from Cadmium Yellow Medium and Mars Black. Use an even darker green, made from Viridian and Alizarin Crimson, to paint the darkest areas. Work a little more on the water, adding darker and lighter areas using the same brush and mixture used to paint the water in Step 4. Define the shapes and colors of the rocks with the colors and brush used to paint the rocks in Step 2.

DETAIL OF BACKGROUND WATER

In this close-up of the water you see how water travels around rocks. The movement causes white water to form on either side of the rock, resembling wings. Other details to note here are the highlights on top of the rocks, and the slight mixing of rock color in the water below the rocks.

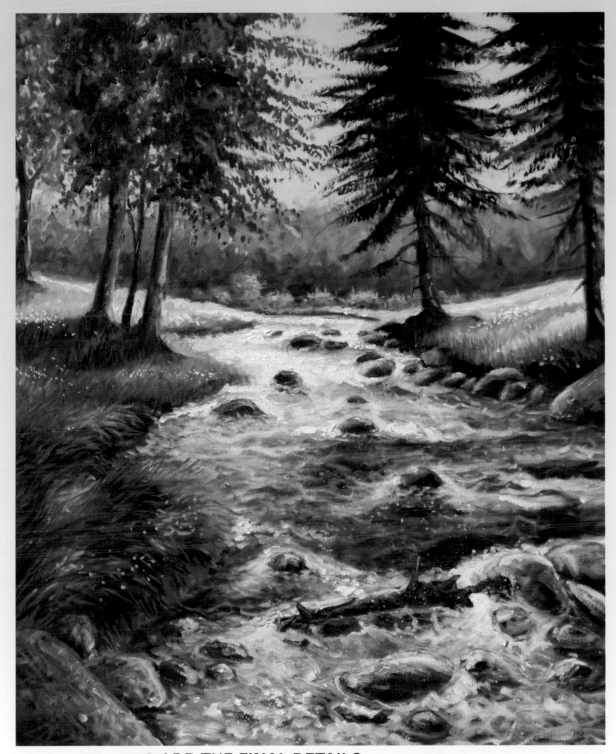

6 ADD THE **FINAL DETAILS**

Now, using the same colors and brushes, you're ready to do the finishing touches. Put some lighter green on the left trees to give them dimension. Use a very light gray to put highlights on the rocks and use darker color for the shadows. Using a mixture of Cadmium Orange, Raw Umber and Prussian Blue, paint more detail on the tree trunk caught in the rocks. The water should now have some defined dark- and light-blue areas. In the areas where the water is rushing quickly it will have foam, which you'll paint with Titanium White. In areas where the water is deep, it will be a very dark blue.

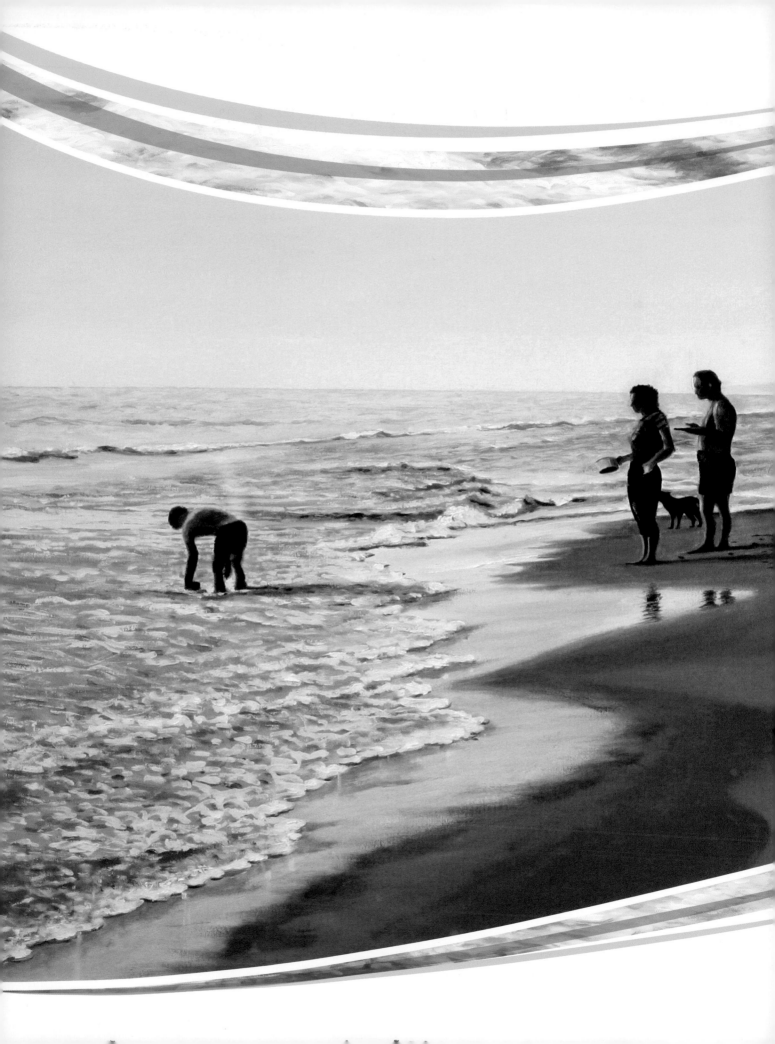

LARGE **LAKES,** **SEAS** AND **OCEANS**

Ah, the drama of the sea! The rolling waves dipping and arching towards the sky—there is nothing like it! I've perched myself on the deck of my boat many times and watched the drama unfold around me. It's an indescribable experience that I find I can depict best with my paints and brushes.

Painting the oceans and Great Lakes means painstakingly studying how waves are born, how they behave and how they finally meet their end. It means observing the smallest ripple and the crashing breaker. There can be no more exhilarating experience to a painter than to capture such a scene.

I know that for most of you who have invested in this book, this chapter is probably what you've looked forward to the most. Take the time to read and reread it. Think about it and, if possible, take it with you to the shore. Observe the water first hand so that it will sink deeply into your being. Take your pencil and sketchbook and copy some of the illustrations. Finally, I hope that you'll actually paint the demonstrations. As you paint the strokes you'll begin to feel the waves as they appear beneath your brush.

In sailing circles, there's a common phrase one gives to a fellow sailor as he embarks on a sailing voyage: "May the wind be always at your back." I would like to give you a new phrase to send you on your painting voyage: "May your brush always go where you ask it to and may your colors mix true!"

THE PICNIC | OIL, 24" × 30" (61CM × 76CM), PRIVATE COLLECTION

PHYSICAL LAWS OF WAVES

To paint them correctly, it's important to understand the physiology of waves. Knowing the terminology will also help you to understand the steps in the following demonstrations. Generally, waves originate from storms and winds. Some storms have their origin thousands of miles away, and some waves can be traced halfway around the world. Storms and winds are related to atmospheric conditions and the currents of the big oceans, all of which contribute to the size and type of a wave.

The water in a wave advances toward the shore very little. The wave's movement is caused by the invisible force of the wind, which lifts the water up and down. And the stronger and faster the wind, the steeper the wave. This was already known to Leonardo da Vinci (1452-1519) when he compared waves of water to waves of wheat, where the wheat itself is rooted to the ground.

The height of the wave is determined by the amount of wind. Most water surface disturbances are caused by movements of the air, usually wind and storms. The Beaufort scale categorizes the movements of the air.

- Calm, with no wind, is the low end of the scale with no waves. You'll only see horizontal lines on the water's surface.
- Light breezes create waves of less than 6 inches (15cm). Here you'll observe more horizontal lines that are wider and slightly broken-up.
- Gentle breezes create waves of about 2 feet (61cm). The waves will begin to look less horizontal and more at an angle to each other. The trough becomes deeper and the crest higher.
- Moderate breezes create waves of about 3 feet (91cm). The angle of the waves becomes steeper. The waves become longer and the trough becomes deeper.
- Fresh breezes create waves of less than 5 feet (152cm).
- Strong breezes create waves of about 6 feet (183cm). Here, the foreground waves will obscure the view of the background waves.
- Near gale winds create waves of 12 feet (366cm).
- Gales create waves of about 18 feet (549cm). These waves will look like walls of water.
- Strong gales create waves over 22 feet (671cm) that are impressively high.
- Storms to hurricane force winds create waves of over 40 feet (1,219cm). Hopefully most of us will never experience that!

Each of these disturbances affects the surface of the water in a different way. As painters, we must examine these different waves and determine how to re-create them on our painting surface.

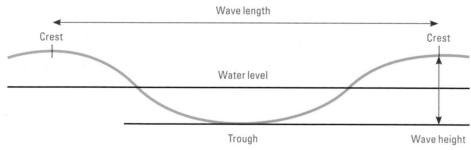

MEASURING WAVES

Waves are measured by their height, their length and their *period*, or the time required for the top of one wave to reach the point passed by the wave ahead of it. Oceanographers and sailors use the term *fetch* to describe the distance a wave travels from its origin to where it meets its first obstacle. The longer the fetch the higher and greater the wave length. The height of a wave is measured from its *trough* (the lowest point) to its *crest* (the highest point).

WAVES OF DIFFERENT SIZES AND SHAPES

Waves come in different sizes and shapes that are largely determined by the amount of wind present. As a painter, it's important to examine these differences and determine how to re-create them on your painting surface. Below is a chart of different waves to help you in your understanding.

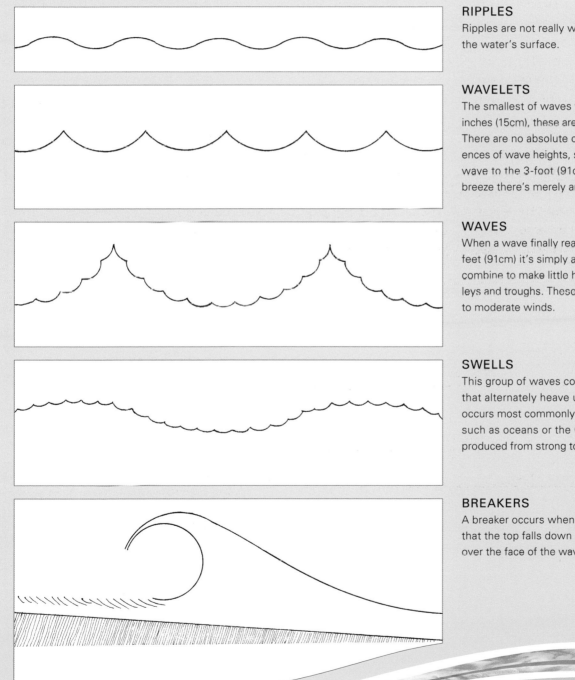

RIPPLES
Ripples are not really waves, but irritations on the water's surface.

WAVELETS
The smallest of waves with heights of about 6 inches (15cm), these are created by light breezes. There are no absolute or sharply defined differences of wave heights, so from the 6-inch (15cm) wave to the 3-foot (91cm) wave of the gentle breeze there's merely an increase in size.

WAVES
When a wave finally reaches a height of about 3 feet (91cm) it's simply a bunch of wavelets that combine to make little hills of wavelets with valleys and troughs. These are produced by gentle to moderate winds.

SWELLS
This group of waves consists of areas of waves that alternately heave up and sink down. This occurs most commonly in larger bodies of water such as oceans or the Great Lakes. Swells are produced from strong to gale-force winds.

BREAKERS
A breaker occurs when the wave gets so high that the top falls down and crashes, or breaks, over the face of the wave.

HOW TO **PAINT WAVELETS**

Learning to paint wavelets, the small waves on the surface of the water, is a good introduction to painting waves. Practice making a series of movements that simulate wavelets. Begin by making shallow figure eights, which I call the eight stroke method. Use only a pencil and paper and practice until you've filled the page with eight strokes. Do these quickly and without hesitation so that it becomes almost mechanical.

Since light affects the wavelets it's important to determine where the light is coming from. As with all objects, the part of the wave that is hit by the light will be lightest. As the wave moves away from the light and is in shadow, it will be dark.

Also remember that waves and wavelets must follow the rules of perspective. Closer objects appear larger and distant objects appear smaller. The farther away the wave, the smaller and narrower the eight strokes will be and vice versa.

EIGHT STROKES

Using ink or watercolor, try to make your eight strokes with a brush. This time, lift your brush each time you make a curve. You'll end up having a series of what appear to be shallow x's. Fill the page with these shapes.

WAVE ILLUSIONS

As you look at the series of strokes on your page, you'll begin to see the illusion of waves. Repeat this exercise until you feel confident—you'll be using these very strokes to create waves in the following paintings. Notice that I begin at the top with eight strokes, but as I progress down the page, my strokes start to look like shallow x's.

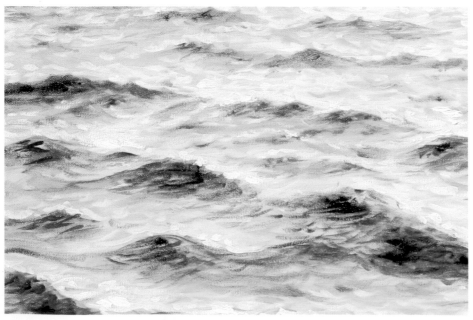

PAINTING WAVELETS WITH THE EIGHT STROKE METHOD

To practice painting the eight stroke method, use a no. 2 sable round with some Ultramarine Blue and turpentine oil medium to create the strokes. Press down on the brush for a thick line; release the pressure for a thinner line.

As you move toward the bottom of your page, begin to put down your brush only on the lower part of the eights. You will be making an eight with your brush in the air and then dropping your brush down for the lower part of the eight to create the appearance of a shallow x.

Use light values to create the highlights and darker values for the areas in shadow.

Open Sea Wavelets and Waves

This arrangement of waves and wavelets on the open water illustrates perfectly how waves act and react. The many small wavelets combine to become larger waves, which peak and catch the light. Mastering these waves is essential if you want to paint believable water.

MATERIALS LIST

OILS
Payne's Gray, Prussian Blue, Titanium White, Ultramarine Blue, Viridian

SURFACE
Canvas primed in acrylic

BRUSHES
1½-inch (38mm) flat house-painting brush, several no. 4 hog bristle brights

DEMONSTRATION | OIL

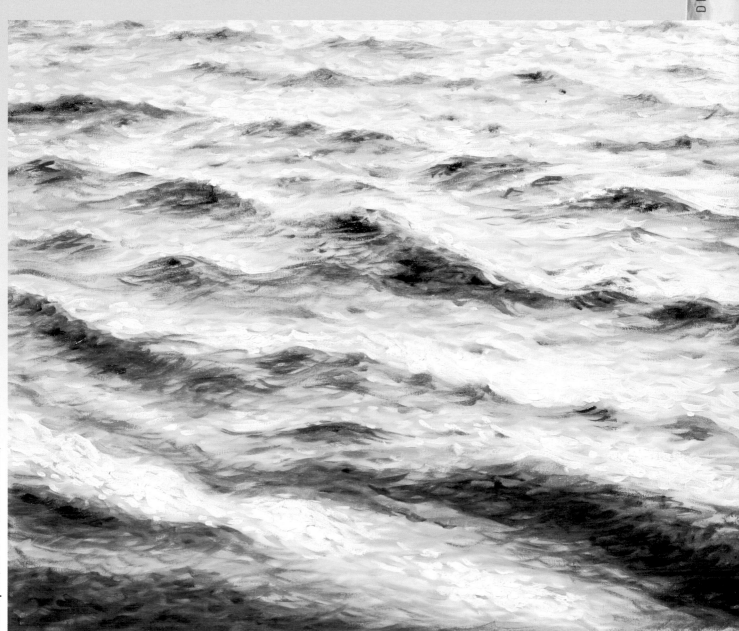

WAVE | OIL, 20" × 24" (51CM × 61CM), PRIVATE COLLECTION

1 ADD A **BASECOAT** AND PAINT THE **LIGHTS**

Create a medium value mixture of Payne's Gray, Viridian and Titanium White. Make sure to mix enough to cover your canvas. Use a 1½-inch (38mm) house-painting brush to cover the canvas with an even coat of paint. You can also underpaint with acrylic, since you'll be completely covering the canvas with oil later. (Remember, any canvas can be under-painted with acrylic since the canvas is primed in acrylic anyway.)

Create an off-white with a mixture of Titanium White and a touch of Viridian. With a no. 4 bright, use this mixture to establish the waves' highlights. The light is coming from above to the right so begin at the top right corner, working back and forth with small eight strokes.

Moving down toward the left foreground, make the eight strokes farther apart and larger. In the illustration you can see that the strokes are at an angle and that space is left between these light areas.

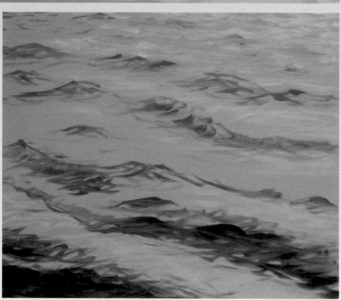

2 PAINT THE **DARKS**

Now use a combination of Viridian, Ultramarine Blue, Prussian Blue and a little Titanium White to paint the dark areas between the white areas with a no. 4 bright. Start in the lower left corner using the eight strokes. This will be the darkest and largest area since it's closest to the viewer. As you work up and to the right, make your strokes smaller and lighter by adding some more Titanium White.

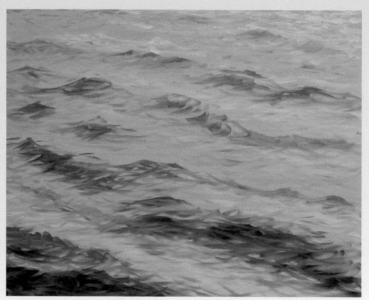

3 ADD THE **MEDIUM VALUES**

Add more Titanium White to the mixture from Step 2 to make it a medium value. Go over the areas between the darks with this lighter mixture using the eight stroke and no. 4 bright. Make the brushstrokes larger at the bottom of the canvas and smaller at the top of the canvas to create a feeling of depth.

REMINDER ABOUT VALUE

Just a reminder that value, in painting, means the lightness or darkness of a color. By adding white to a color we make it a lighter value. By adding less white we make the color a darker value. To create a medium value we would add some white, but not too much.

4 ADD THE **WHITE AREAS**

In this step you'll use straight Titanium White. Make sure you've cleaned your brush thoroughly before you begin so you don't mix in any other colors. Also, make sure to wipe off your brush frequently as you work. Make small, angular strokes of Titanium White on the bottom between the darks with a no. 4 bright. Wipe off your brush. Go to the next area and put in more Titanium White strokes. As you work upward between the darks, leave some of the medium values.

5 DEFINE THE **WAVES**

Now you'll begin to see the waves. Using your dark mixture from Step 2, define the waves more clearly with a no. 4 bright. Finally, add more Titanium White to the tips of the waves. Go back and forth with your darks and lights until you're happy with the results.

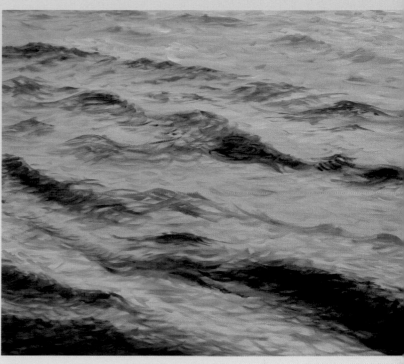

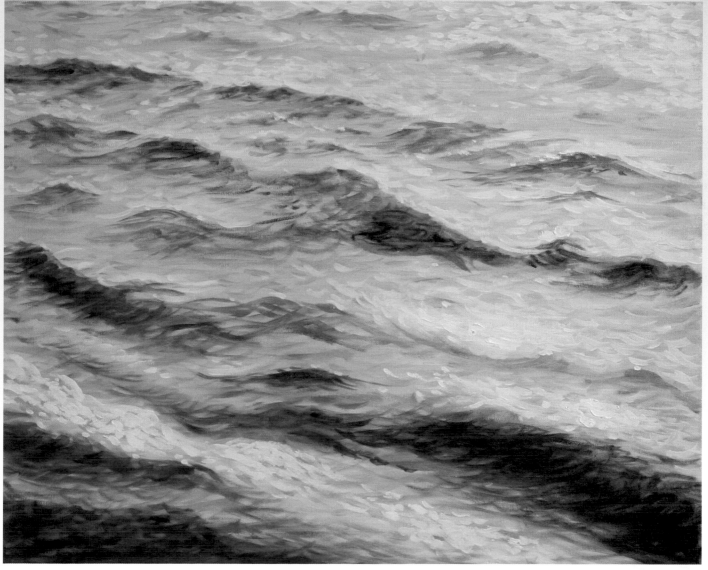

THE **BREAKER**

Breakers are the most dramatic of all waves. While you most often see them as they crash onto the beach, they can happen anywhere. Breakers occur when the wind pushes a wave, causing the wave to get so high that its top moves faster than its bottom making it fall down at the front (or *face*) of the wave.

When you stand on the beach and watch the surf you can see that not all waves running up on the beach will "break." Waves must attain a certain height to become breakers. Remember, waves are not independent entities, but are initiated by the force of wind. The water of a wave doesn't really move forward. If you think of water as a collection of drops you would see that they hardly move at all, but rotate in an elliptical pattern.

HOW LIGHT AFFECTS THE BREAKER

When we attempt to paint a breaker we must consider not only its physiology, but also how the light will affect the image. In most cases, light will appear from above, as in the light that comes from the sun or the moon. This light will hit the top of the wave. If the light is coming from the back, however, the wave is backlit and will appear to be much darker. In the black-and-white illustration on this page you can see how light will affect a breaker.

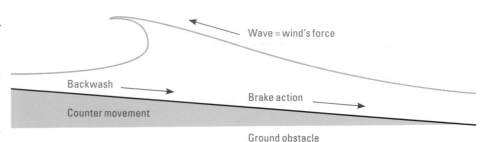

ANATOMY OF A BREAKER

When the breaker runs up onto the beach two forces come into play. On the top, the wave is being pushed up as the bottom of the lake or beach gets higher toward the shore. The water that's being pushed by the wind can't go anywhere but up. When the swell hits the beach it builds up or *peaks*. The top goes faster than the bottom and collapses over the face and "breaks." At the same time, aiding the forward movement of the wave, all the water that crashed onto the beach from the previous wave now runs back to the sea in the opposite direction. This added backward force from beneath increases the movement of the wave and it collapses. The illustration above demonstrates this phenomenon.

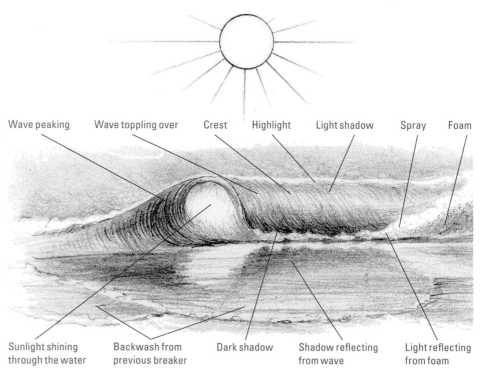

LIGHT HITTING A BREAKER

In this illustration we can see the light from the sun hitting the top of the breaker from behind. The front of the breaker is darker because it's hidden from the sun. Notice the sunlight coming through the breaker and the reflection on the flat water in front of the breaker.

Crashing Breaker

This is a classic example of a breaker as it topples toward the beach of the shore of a Great Lake. Just the sight and sound can take your breath away. As an artist, you cannot re-create the awesome sound, but instead have to rely on your skills and knowledge to visually re-create it.

One way to capture the drama is through the use of contrast, placing strong lights and darks next to each other. Having a darker value behind a light one will make the light even more dramatic.

MATERIALS LIST

OILS
Burnt Sienna, Cobalt Blue, Prussian Blue, Titanium White, Ultramarine Blue, Viridian, Yellow Ochre

SURFACE
Primed canvas

BRUSHES
Nos. 2, 4 and 6 hog bristle brights, no. 1 sable round

OTHER
Pencil, spray fixative, turpentine oil medium

DEMONSTRATION | OIL

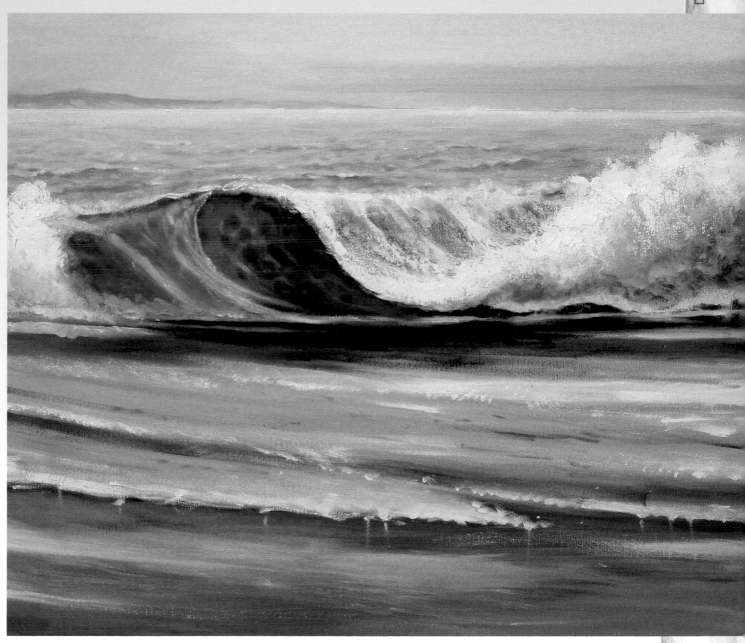

BREAKER ON THE BEACH | OIL, 20" × 24" (51CM × 61CM), PRIVATE COLLECTION

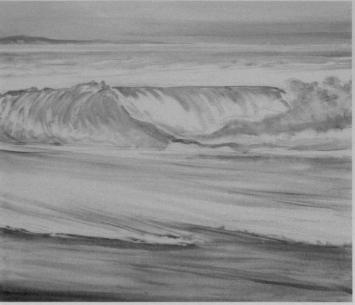

1 DRAW THE SCENE

Using a pencil, first draw the horizon line in the background, making sure that it's level. Draw a small area of land on the left of the horizon line, then draw a line for the top of your breaker, which will be slightly angled up toward the right. Imagine the breaker as a tube and draw the water running over it. Put in some waves crashing up and a line at the bottom for the edge of the beach. Spray with fixative when the scene is complete.

2 ESTABLISH THE COLORS

Using a no. 6 bright, paint some pink sky with a mixture of Burnt Sienna and Titanium White. Apply the paint on the left, pulling to the right but not all the way across. Save this mixture to use later. Mix Titanium White with Ultramarine Blue then add touches of Prussian Blue and Viridian. Use this to paint the right side of the sky, pulling the paint from right to left, but not all the way across. Thin this mixture with turpentine and use it to paint the top of the water, the breaker and the edge of the water on the beach. Use your pink sky color with some Yellow Ochre and Titanium White added to paint the beach using a no. 6 bright.

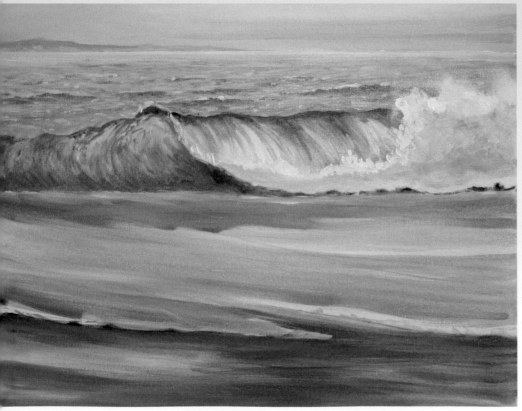

3 PAINT THE WATER

Use a no. 2 bright with the blue mixture from Step 2 (but with less Titanium White) to paint the small waves behind the breaker with horizontal shallow eight strokes. Keep this area lighter than the breaker.

Paint the darks of the breaker with your blue mixture, adding some Viridian. Drag the no. 2 bright following the wave's direction to help define its shape. Paint the shadow beneath the wave using the blue mixture from Step 2, but with some Cobalt Blue added.

4 PAINT THE **FOAM** AND DEFINE THE **BREAKER**

Stipple the foam in front of the breaker with a no. 2 bright and a mixture of Cobalt Blue, Viridian and Titanium White. Lay this color into the foreground water in wide, horizontal strokes. With a darker mixture of Cobalt Blue and Viridian, start pulling in darks in the underside of the breaker.

Now push the contrast of the breaker even further to create a feeling of drama. Paint even darker areas of Cobalt Blue and Viridian where the breaker folds over. Use pure Titanium White on the top of the foam and drag some of the Titanium White on the very edge of the water in the foreground to create the foam. Add some Yellow Ochre and a touch of Burnt Sienna to the foreground sand with a no. 4 bright. Use this same mixture plus some Titanium White to blend in several streaks across the water on the beach.

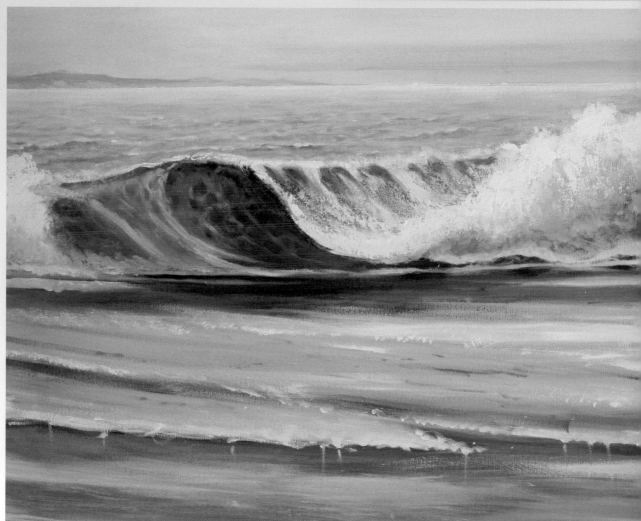

5 ADD THE **FINAL DRAMATIC TOUCHES**

Using pure Titanium White, create the spray of the wave (see page 84). Add more dark blue from Step 4 below the foam to create a shadow using a no. 2 bright. Place small dots of Titanium White on the edge of the shore and where the water meets the sand with a no. 1 round. Add short, vertical lines of Titanium White below the dots to create sparkly reflections on the wet sand.

WAVES AND PERSPECTIVE

As discussed before, waves must follow the rules of perspective to look realistic. Waves that are farthest away from the viewer should, in general, be smaller than those closest to the viewer. The closer, larger waves might actually overlap waves that are farther away.

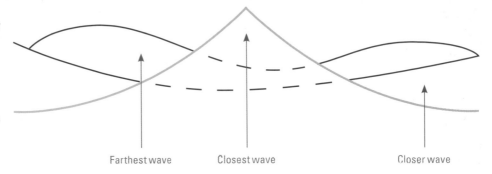

Farthest wave Closest wave Closer wave

PERSPECTIVE AT WORK
The broken lines show the area that's hidden by the wave in front of it. The closest wave is lower than the others and we seem to see it from above.

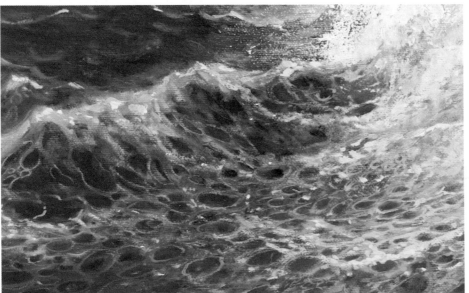

"BOILING WATER"
Here you can see the foam from both breakers as they flare back into the regular waves. Note also the round, dark shapes on much of the water. This is called *boiling water*, a term taken directly from the appearance water has in a large pot of boiling water.

BIGGEST WAVE
Here you can see the highest wave. Create the foam on the top of the huge wave by using your fingertips to dapple the white paint onto the wave.

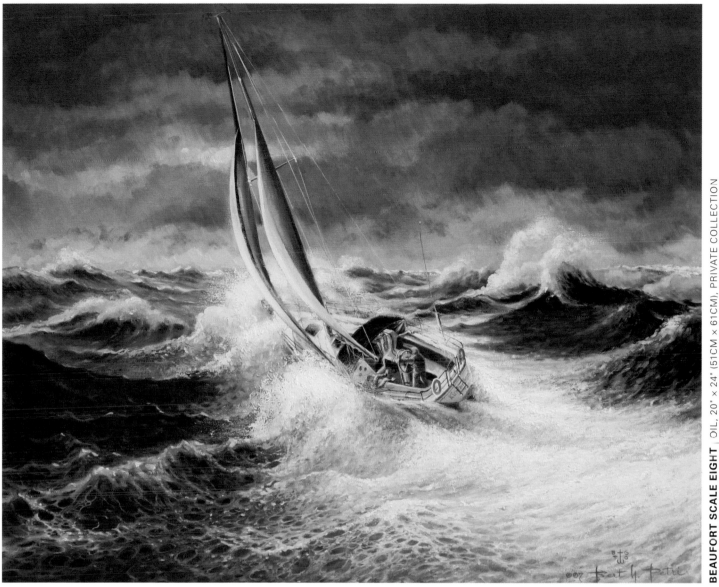

RE-CREATING WAVE SCENES

I based this painting on an experience I had while sailing with my son, Eric. Because Lake Michigan is relatively small compared to the ocean, the waves are choppy as they bounce back and forth. The winds during this storm were nearly gale force, so the waves were high. The boat's bow dove into one of these huge waves and then was slammed at the same time by another one at the port quarter. No one was there to take a photo, of course, so I had to re-create the scene in my mind. If you're a sailor and familiar with the seas and what they do to your vessel, it's not difficult to do. If you're not a sailor, analyzing photos of water is useful.

SPRAY AND FOAM

SPRAY

Let's look more closely at what happens when a wave crashes. As you have learned, the breaking of a wave is caused by the top of a crest moving faster than the wave itself, causing the water to topple forward. This concave, forward motion will eventually complete a full circle, enclosing an air space. The top of the wave will strike the water surface in front with great force, at times throwing spray up higher than the wave itself. This high spray is increased further when the enclosed air is compressed and reacts like bellows, blowing spray high into the air.

FOAM

Foam consists of small droplets of water that act much like bubbles in the way they reflect light. What you see as white water or foam is really reflection of the light on many droplets of water. Not only can you observe the reflection on the top of each droplet, you can see the reflection through the droplet on the inner surface below. The more bubbles, the more reflected light.

SPRAY AND FOAM BUBBLES
This illustration of soap bubbles done with white pencil on black paper demonstrates how much white there really is in just a few bubbles. Both foam and spray is made up of water bubbles. For spray, the bubbles are separated, and for foam, the bubbles cling together.

TECHNIQUE FOR PAINTING SPRAY
Paint the spray using a no. 6 or larger hog bristle flat. Make a loose, soupy mixture of white paint, Liquin and turpentine. Pick up as much paint as possible with your brush, and with your index finger press the bristles back and let them fling forward while at the same time directing the spray onto the painting surface. Do this when the remainder of the painting is dry, so you can wipe off any spray that doesn't land in the desired location with a clean rag. Practice this method on another surface before actually doing it on your painting.

TECHNIQUE FOR PAINTING FOAM
You can paint foam in a variety of ways. The more common technique is to stipple the paint onto the surface using a stiff bristle brush, pushing the tip onto the surface in a quick, skipping movement. Do this when the painting is dry to give the foam the final highlight. If you're handy with a painting knife you can create the same effect by pulling the knife over the surface. Use a light, gentle touch in a skipping manner for both techniques.

Open Ocean With Whitecaps

Part of what makes painting water challenging is the fact that it never stays still. Waves on the open sea are constantly renegotiating the space as they move up, down and sideways. Using the analysis on page 82, you can make some sense out of what otherwise seems chaotic. The large wave in the foreground is covering up some of the wave movement behind it. This overlapping suggests that the wave is in front of the other waves.

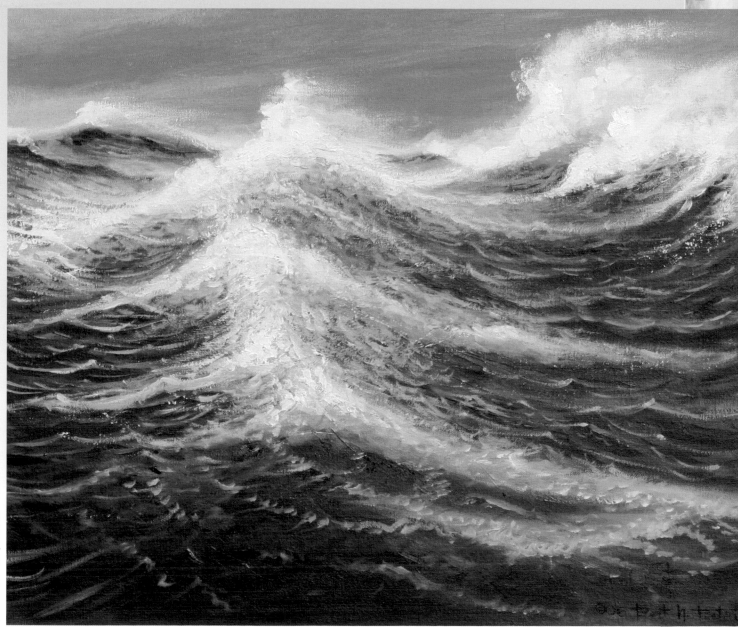

OPEN WATER | OIL, 20" × 24" (51CM × 61CM), PRIVATE COLLECTION

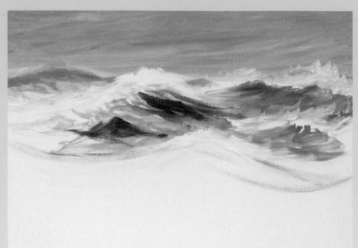

1 ADD THE **SKY** AND BEGIN THE **WAVES**

Before you begin painting the waves, paint the sky using a no. 8 bright and a mixture of Titanium White, Prussian Blue, Ultramarine Blue and a touch of Viridian. Apply the paint using wide, horizontal strokes.

Begin painting the waves using the same colors, but mixing in less Titanium White. As you paint the waves, make sure you follow the rules of perspective. Use an upward stroke, working in the back waves first and leaving white areas for the highlights and foam.

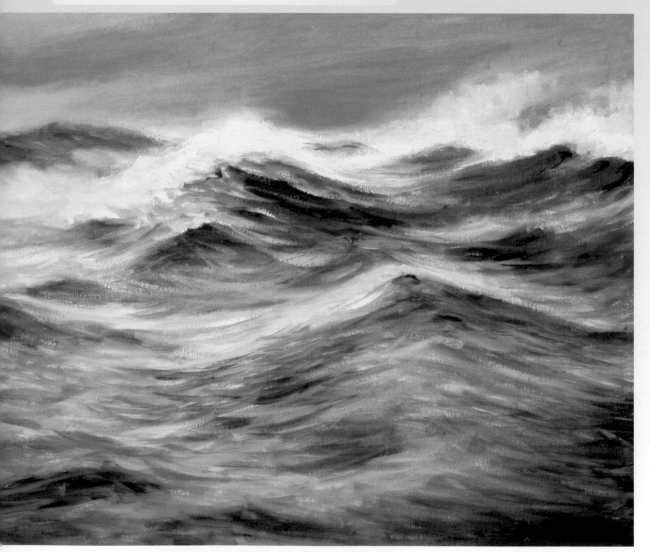

2 FILL IN THE **FOREGROUND**

Using varying shades of the wave mixture from Step 1, paint the lower half of the foreground using the eight stroke method (see page 74). Don't worry about detail at this point. Just cover the lower half with a good amount of paint.

As you can see, the tops of the waves are always lighter, which means adding more Titanium White to your basic water mixture. Use very little Titanium White for the shadow side of the waves.

3 DEFINE THE **WAVES**

Now you can begin to form defined waves. Create a swell in the lower half of the painting by using Titanium White, applying the paint from the top of the swell down each side with a no. 6 bright. Begin putting some Titanium White on the tops of the upper waves in the background, and some dark blues from Step 1 in the deeper parts of the waves. You can almost feel the rise and fall of the water as you do this.

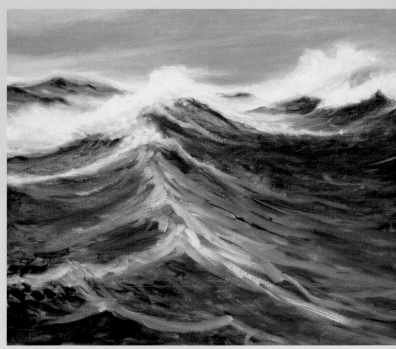

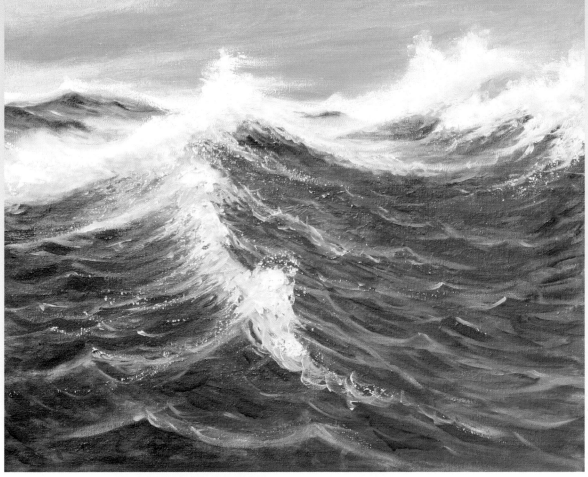

4 ADD THE **SPRAY**

Using straight Titanium White and a no. 4 bright, lay in some crests on the waves. Imagine that the wind is blowing from the left of the picture, so paint the spray in the opposite direction. Push and pull the smaller waves using alternating dark and light paint from Steps 2 and 3.

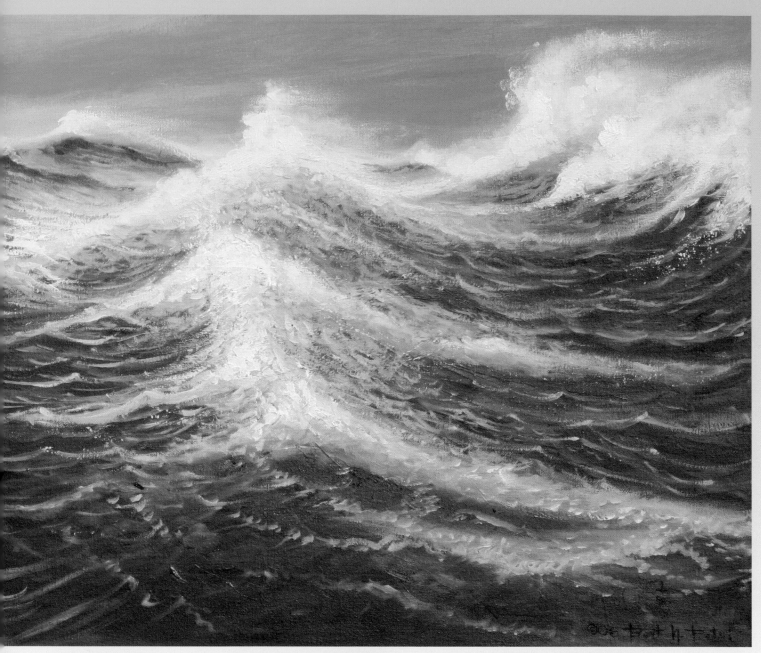

5 ADD THE **FINAL TOUCHES**

Add more depth to the waves by working back and forth from darks to lights until you're satisfied with the results. Don't get discouraged—it may take awhile to achieve the right effect.

DETAIL OF SPRAY

In this close-up you can see exactly how the spray looks in the painting. Add Titanium White to the tops of the waves and draw them to the right as if the wind were blowing off the tops. Deepen the dark areas by adding straight Prussian Blue with a little Ultramarine Blue.

Crashing Breaker on a Sandy Beach

During a windy day, the seas can get pretty wild. Capturing a scene like this one requires knowledge, skill and patience.

To successfully paint this scene you'll need to pay attention to what you've learned in previous pages, especially the handling of spray techniques, since spray takes up much of the composition.

MATERIALS LIST

OILS
Alizarin Crimson, Burnt Sienna, Cadmium Yellow Light, Payne's Gray, Prussian Blue, Titanium White, Ultramarine Blue, Viridian, Yellow Ochre

SURFACE
Primed canvas

BRUSHES
Nos. 2, 4, 6 and 8 hog bristle brights, no. 6 hog bristle blender, nos. 0 and 2 sable round

OTHER
Liquin, pencil, ruler or straightedge, turpentine oil medium

DEMONSTRATION | OIL

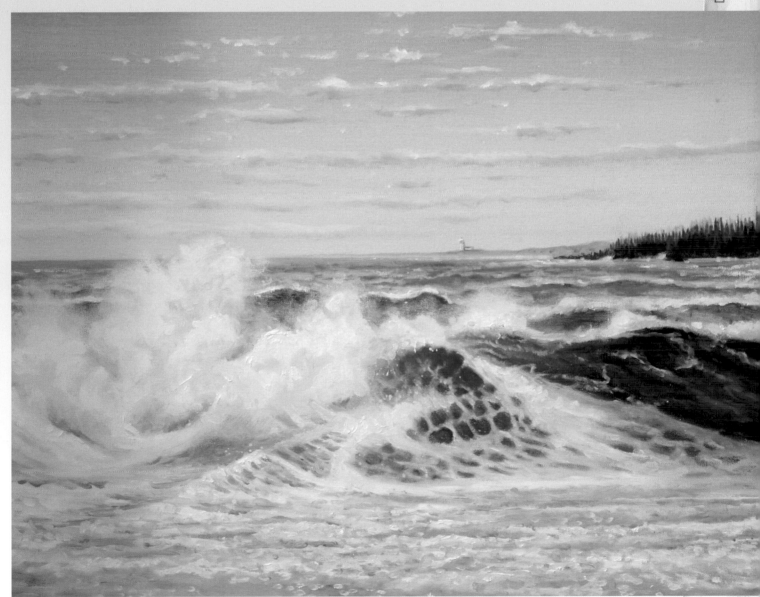

WILD SHORE | OIL, 24" × 30" (61CM × 76CM), PRIVATE COLLECTION

1 SKETCH THE SCENE

With a pencil, begin by establishing your horizontal line for the horizon. Use a ruler, straightedge or mahlstick to make sure your horizon is level.

Instead of using fixative, use a mixture of Viridian, Ultramarine Blue and Titanium White thinned with turpentine, to paint over your horizon line with a no. 2 bright. Use the same mixture but with a no. 0 round to paint some trees and a small lighthouse in the far distance. Leave most of the scene for the water since it's the main subject. Loosely paint the waves with the same mixture and a no. 8 bright.

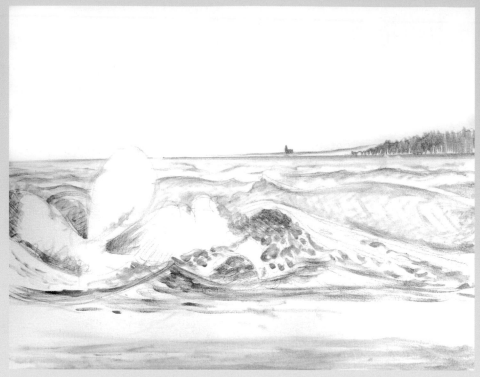

2 PAINT THE SKY

Paint the entire sky with Titanium White using a no. 4 bright. Try to create an even paint surface by going back and forth with your brush. When you have an even surface of paint, mix a large batch of Ultramarine Blue with a touch of Prussian Blue and Titanium White on your palette. Begin to add this light blue mixture to the top of the sky and work downward. The sky should be darkest at the top and get lighter near the horizon, so use less blue in your mixture as you work down.

Use this mixture to start painting the waves. Follow the sketch to fill in the dark areas of the waves with a no. 4 bright. Add some sand with thinned Yellow Ochre and a no. 4 bright to indicate the beach.

3 BEGIN **REFINING** THE **WAVES**

Mix some Viridian with a touch of Prussian Blue and Ultramarine Blue and thin this mixture with Liquin and turpentine. Following the lines of your drawing, use this mixture to create the waves. You will not be using Titanium White at this point, but should leave the areas to be white as bare canvas.

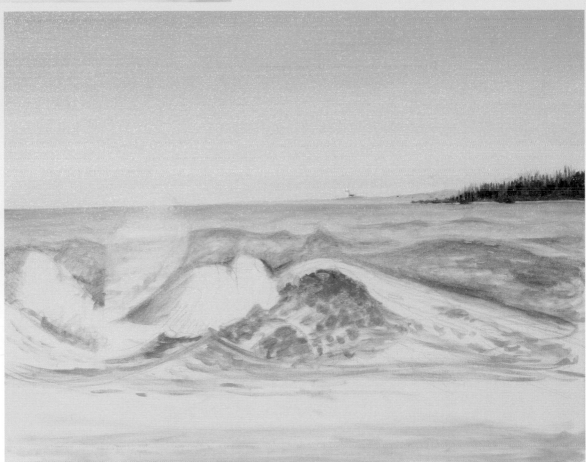

4 REFINE THE **BACKGROUND**

Add some Alizarin Crimson to your Prussian Blue, Viridian and Ultramarine Blue mixture and darken the background trees with a no. 0 round. Use vertical strokes to suggest the trees and add a little Burnt Sienna to the bottom for the land. Add the trees' shadows with the light blue mixture from Step 2 but with less Titanium White. Add more Titanium White for the light areas of the lighthouse using a no. 2 round.

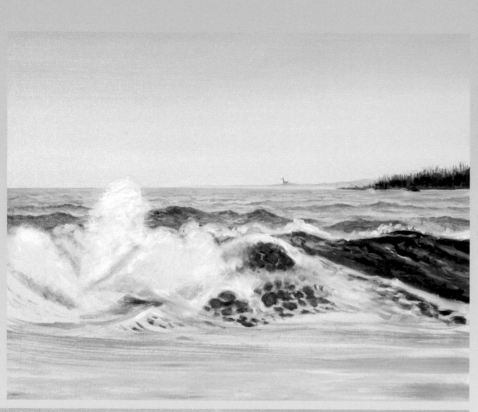

5 DARKEN THE WAVES

Use the same blue and green mixtures from Steps 1 and 2 to paint the water behind the waves. Add more Titanium White to your mixture to make this lighter than the water in the foreground. Notice the spots of blue in the lower part of the waves. This is where the foam begins to form. With your no. 4 bright, paint these blue spots using the light blue mixture from Step 2 but with less Titanium White.

Use Burnt Sienna with Titanium White, and with a no. 6 bright, paint the sand below the wave in wide, horizontal strokes. Add some streaks of the light blue mixture for interest.

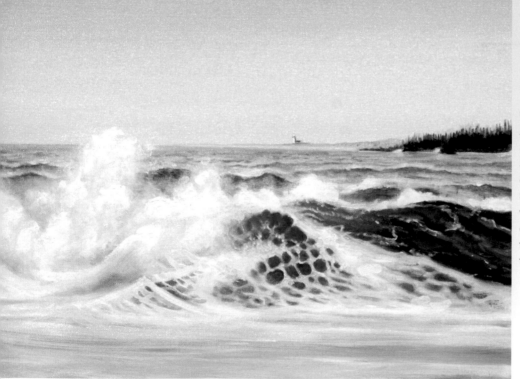

6 ADD THE SPRAY

Add Titanium White to the spray area using a no. 4 bright for the large areas. The spray areas will also have some shadow in the depth of the wave. Use your light blue mixture from Step 2 to paint this area. Work back and forth with your darks and lights to get the realistic effect you want. Be patient. Use a no. 2 round to work the Titanium White around the holes in the front wave that you established in Step 5.

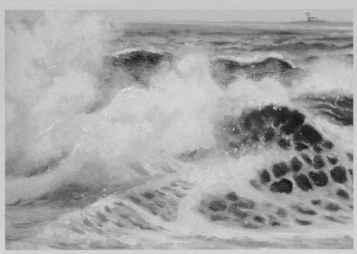

7 FINALIZE THE BREAKER

Create yellow-green areas where the wave thins out and the sunlight flickers through. Use some Cadmium Yellow Light with a touch of Viridian to achieve this effect. For the areas of deeper water, add some Alizarin Crimson to Prussian Blue and work it in with a no. 8 bright.

DETAIL OF FOAM

This close-up of the foam at the bottom of the painting gives you a better idea of what the lower part of the painting will look like when you're finished. Notice the spots of white here. This is a good way to finish up your painting.

8 ADD THE FINAL TOUCHES

Simulate the foam on the beach by running your no. 6 bright loaded with Titanium White across the surface in a horizontal, skipping movement, twisting as you go. Add some darker areas of Yellow Ochre to the foam. Use Payne's Gray for the clouds' shadows and Titanium White for the lights. Apply these colors with a no. 4 bright. Either rub your finger across the surface or use a no. 6 blender to blur the clouds in the background.

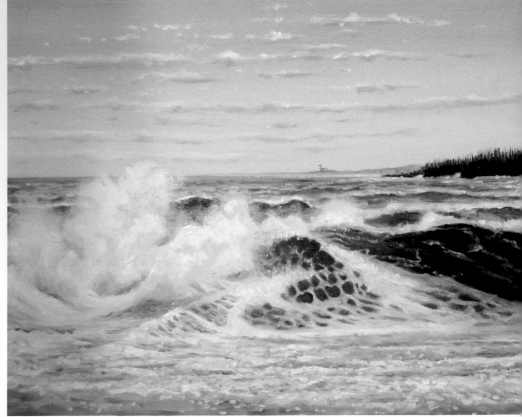

PAINTING THE **WATER'S EDGE**

Painting the shoreline presents the artist with particular challenges. Painting the wave as it moves onto the shore and makes the sand below it wet, and painting the wave's reflection in the wet sand are two such challenges. Here is where observation comes into play. If possible, spend some time observing the shore next time you're at the beach, or look at photos or paintings of water. This will go a long way to helping you understand what happens on the shore.

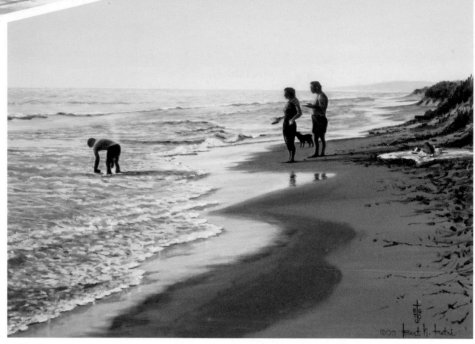

THE PICNIC | OIL, 24" × 30" (61CM × 76CM), PRIVATE COLLECTION

WAVES HITTING THE SHORE

This is one of my favorite paintings, probably because of the relaxed mood it conveys. It also illustrates some of the factors that come into play when painting a shoreline, such as re-creating the water hitting the shore and the wet sand.

SHADOWS AND LIGHT

The edge of the wave as it comes to the shore, though small, does have some depth. This means it will cast a small shadow onto the wet beach, so use a dark water shade here.

Additionally, the foam at the water's edge catches the sunlight and creates little flickers of light that are reflected in the wet sand below. Paint these by putting in small dots of white and then dragging a perfectly vertical white line below it. It's like magic!

REFLECTIONS AND SAND

The flat, light area of sand in front of the receding wave is very wet, causing it to reflect light from the sky. The wet sand acts like a mirror, so the figures behind it are reflected. Paint this area the same color as the sky, then put in the reflection. The area farther up the beach is darker because it's still wet from the withdrawing wave. However, much of the water has been drawn into the sand, making it dull rather than shiny. This means that this area should be painted a darker shade.

Shoreline at Evening

This scene is typical of many shorelines. In painting it you'll make use of everything you've learned so far in the book. How to paint the horizon, the eight stroke method, reflections and painting the water's edge all come into play here. Refer to previous chapters as often as you need to.

MATERIALS LIST

ACRYLICS
Alizarin Crimson, Burnt Sienna, Prussian Blue, Ultramarine Blue, Titanium White

SURFACE
Primed canvas

BRUSHES
Nos. 2, 4, 6 and 10 hog bristle brights

OTHER
Pencil

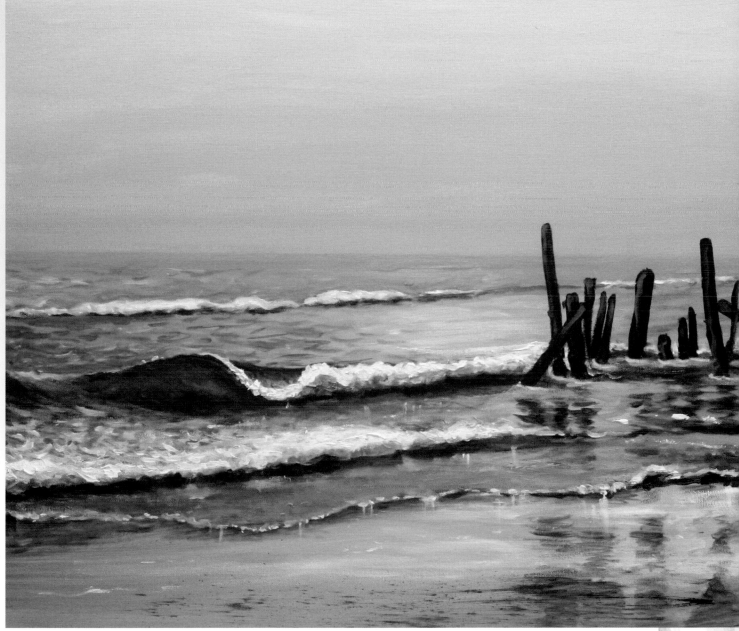

PINK BEACH | ACRYLIC, 20" × 24" (51CM × 61CM), PRIVATE COLLECTION

1 PAINT THE **SKY** AND **BACKGROUND**

Establish the horizon line two-fifths of the way from the top, making sure that it's level. Draw the lines of the water with a pencil, keeping the waves at an angle.

Use a mixture of Titanium White and a small amount of Burnt Sienna to paint a light warm sky with a no. 10 bright. Add the water farthest from the viewer using more Burnt Sienna in your mixture and a no. 6 bright.

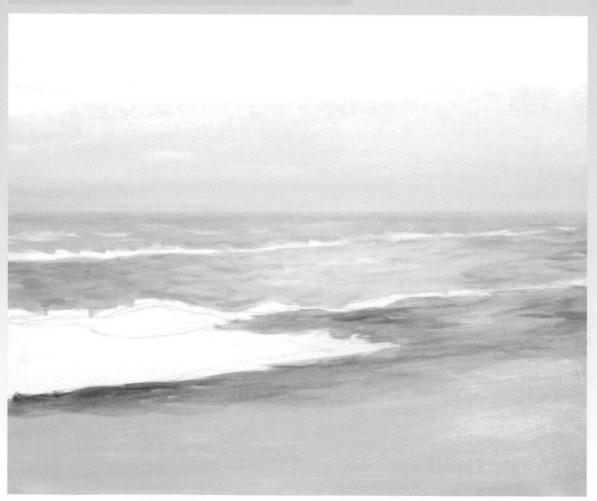

2 UNDERPAINT THE **FOREGROUND**

With a no. 6 bright, add more Burnt Sienna to your mixture so that it has even less Titanium White. The darkest color should be directly below the waves to represent their shadows. Leave the canvas white where there will be white areas on the waves.

3 DEFINE THE **WAVES**

Use Titanium White to fill in the tops of the waves. Let your no. 4 bright follow the flow of the wave. Use a darker mixture of Burnt Sienna and Titanium White to paint the shadow below the waves and below the crest of the small breaker. Make the shoreline water even darker by stippling in with a few ripples of Titanium White on the edge.

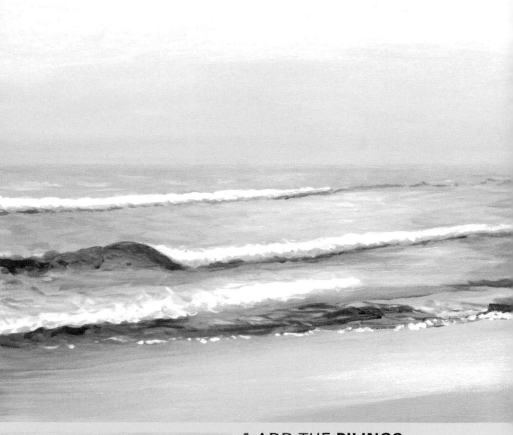

4 ADD THE **PILINGS**

Make short, horizontal strokes with a no. 2 bright and Burnt Sienna to establish some old wood pilings on the right. Bring the reflections down to the bottom of the painting. Using Titanium White, make more strokes over the dark ones to create highlights. Work back and forth from light to dark until you're satisfied with the results.

5 REFINE THE **PILINGS**

Mix Burnt Sienna with touches of both Prussian Blue and Alizarin Crimson and begin to darken the pilings with a no. 2 bright. Concentrate on the lower right side of each piling. You'll accomplish a strong dark where the piling meets the water. Use this color also for the dark shadow area of the piling. The light is coming from the left side of the picture, so add some highlights of Burnt Sienna and Titanium White to the left side of the pilings. Also, add darks to the shadows where appropriate. Put some Titanium White on the bottom of each piling and draw it out to the right where the water washes against each post.

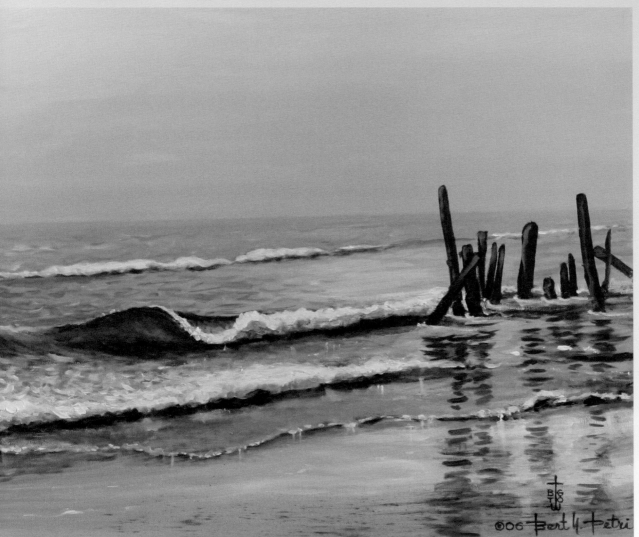

6 ADD THE **BLUES**

Up to this point the painting has consisted mainly of Burnt Sienna and Titanium White. Now, using a no. 2 bright, add some soft blues made from either Titanium White and Ultramarine Blue or Titanium White and Prussian Blue to the edges of the waves where there are shadows on the foam. Also touch up the edge of the water on the shore and the water next to the pilings with some of the same soft blues.

PAINTING **WAVES** WITH **WATERCOLOR**

Painting waves with watercolor utilizes the same techniques and principles we've covered in this chapter. Waves follow the same rules no matter what medium you are working with. The only difference in mediums is the technique and method of applying the paint to the surface. Since watercolor is a transparent medium that's thinned with water, it's important to work from light to dark. Watercolor also dries lighter than when first applied and, once dry, is difficult to change. If you need white areas, you must leave them white or block them out with a masking fluid, though some artists, including myself, use Chinese White for white areas.

For those of you who have never tried watercolor, I say, "Why not?" Life is short and you don't want to miss anything. Give it a shot!

THE TRANSPARENT NATURE OF WATERCOLOR LENDS ITSELF WELL TO WATER SCENES

For many years my wife and I traveled to Florida in the winter. While there, we would often walk the beaches and I would take photographs to inspire me later. This watercolor is a result of a photo I took on one of our walks. I think it's a good example of the lucidity of watercolor. I'm especially proud of the way the waves came out.

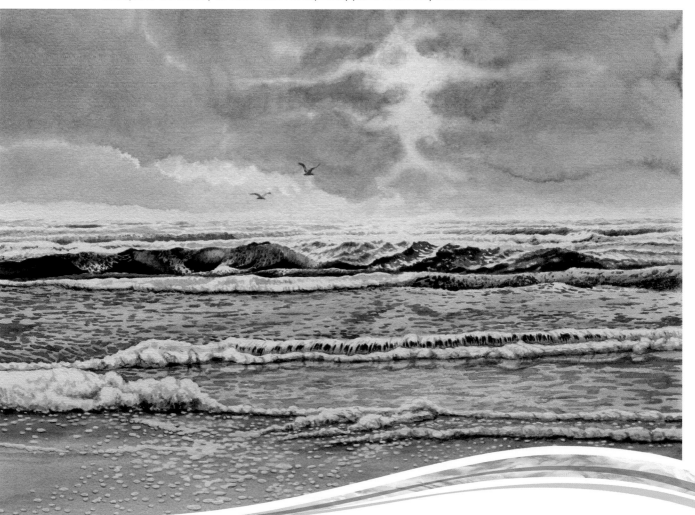

WHERE THE OCEAN MEETS THE SKY | WATERCOLOR, 20" × 27" (51CM × 69CM), COLLECTION OF THE ARTIST

Foamy Waves in Watercolor

This painting requires a lot of Chinese White, an opaque watercolor that is used for the foam of the crashing waves. Some of the Chinese White was mixed with other colors to make those colors opaque. Thus, the painting becomes mixed media, since it's not painted in the traditional manner of watercolor.

MATERIALS LIST

WATERCOLORS
Alizarin Crimson, Chinese White, Cobalt Blue, Prussian Blue, Viridian, Yellow Ochre

SURFACE
Cold-pressed watercolor paper

BRUSHES
1-inch (25mm) flat house-painting brush, nos. 4 and 10 sable rounds

OTHER
Drawing board, mahlstick, pencil, tape

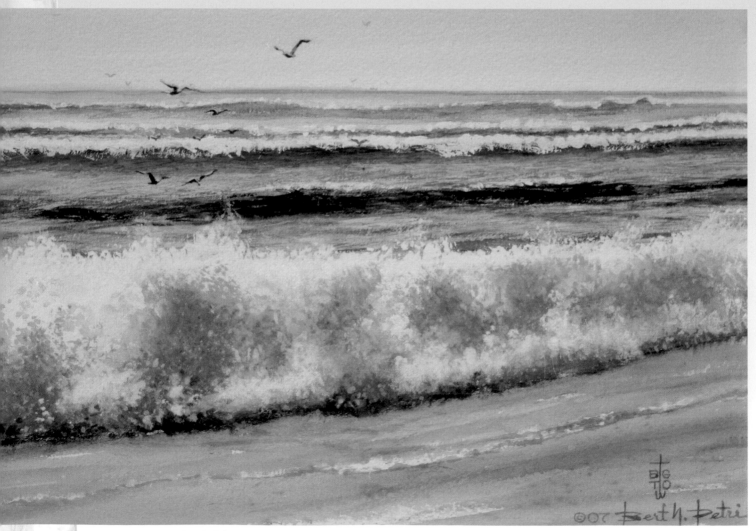

SHALLOW BEACH | WATERCOLOR, 15" × 22" (38CM × 56CM), PRIVATE COLLECTION

1 ESTABLISH THE **SKY** AND **WAVES**

Begin by taping your watercolor paper onto a drawing board, then draw the scene using a pencil. Mix Cobalt Blue and Prussian Blue and apply a wash of this for the sky with the 1-inch (25mm) flat. Tilt the board about 35 degrees so the top is lower than the bottom. The Prussian Blue will float to the top of the picture making it darker. Let it dry before attempting to put in the waves below the horizon.

With a mahlstick (see page 132), add the waves using a no. 4 round. (The mahlstick will help you make a straight line to indicate the horizon.) Paint the waves in narrow strips of Cobalt Blue and Viridian. Add some Yellow Ochre to your blue mixture to create a greenish color, and leave some areas white. Augment the white on the waves with some Chinese White. Make the colors more intense as the waves come closer to the shore.

2 PAINT THE **BREAKER**

Paint the closer waves behind the breaker using a more intense mixture of Cobalt Blue and Prussian Blue. Use the 1-inch (25mm) flat with a combination of Chinese White and the blue mixture from Step 1 to paint the foam on the breaker. The house-painting brush has bristles that are uneven and make perfect foam texture. Push the brush with the paint onto the paper to get the right effect. Use the same blue mixture under the breaker. Now mix some Cobalt Blue and Prussian Blue for the spray and foam. Dab in a mixture of Chinese White, Alizarin Crimson and Cobalt Blue for the shadows.

3 ADD THE **FINAL TOUCHES**

Paint the wet beach with the same colors used for the breaker in Step 2 but with horizontal strokes and a no. 10 round. Go back into the waves and breaker to refine your darks and lights. Lastly you can paint some seagulls—I think they add a bit of interest.

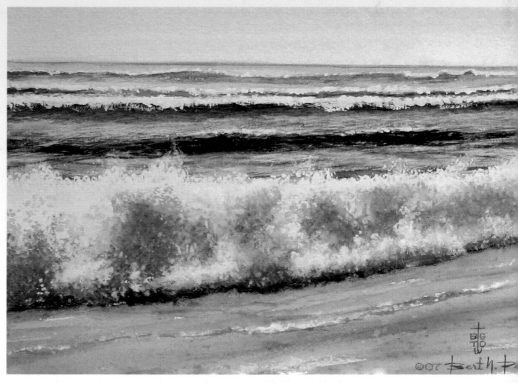

WATERFALLS

What happens when a river or stream ends at a cliff? The water must go somewhere. Water is subject to gravity and also has the characteristic of fluidity. Therefore, it "falls" to a place where it becomes level again. The fall may be a variety of levels descending into a pool.

One of my most treasured memories of a trip to Hawaii is taking a helicopter ride over the island of Maui. The pilot took us into a steep mountain valley where we hovered next to a waterfall. The experience was exhilarating. There's something compelling about the rush of the water as it topples over a cliff, hangs momentarily in the air and then drops dramatically. Maybe you've had such an experience.

Each waterfall has its own character and individuality. The waterfalls of Hawaii are like ribbons falling into lush, green foliage. Niagara Falls has a presence like no other, roaring over the cliff with such force that you almost feel the earth move. The gentle waterfalls of the Great Smoky Mountains take their time as they tumble down successive levels, tripping from side to side as they fall. Capturing each one of these waterfalls in paint has been a joy and a challenge.

Once again, observation is the key to creating the illusion of a waterfall. However, some of us may not have experienced this phenomenon and must rely on others' experiences. Photos and paintings of waterfalls can help. We can also experience the phenomenon of falling water by watching things like a faucet or a fountain. The principles are the same. When observing paintings or photos, we should take note of the vantage point of the artist or photographer. Notice the depth of the water, its color, whether the sky is clear or cloudy, the source of light and the perspective. Contemplate these facts and let them guide you.

In this chapter we'll explore the principles of falling water. As always, take your time and absorb the information, and do some sketching before you begin to paint. Remember that painting is as much a mental exercise as it is a physical one.

Finally, remember that waterfalls behave like water, so all previous rules apply. When painting waterfalls there are always surfaces that will be flat, so treat them as such, with reflections and all other phenomena considered. The falling water itself we should treat like foam or droplets of water.

NIAGARA FALLS | OIL, 40" × 50" (102CM × 127CM), PRIVATE COLLECTION

CHARACTERISTICS OF WATERFALLS

Let's examine the physiology of waterfalls. You learned in chapter two that water seeks to be level. This fact explains the existence of waterfalls—as the ground beneath the water drops down, the water falls over the edge and a waterfall is created.

Waterfalls originate from creeks, streams or rivers. The source may vary from a small trickle to a large, roaring river. In the following pages you'll see a variety of waterfalls of varying sizes, heights and force. You'll also see these waterfalls from different vantage points, lighting conditions and terrains, which are additional features to notice when painting waterfalls.

SIZE AND HEIGHT OF DESCENT AFFECT THE WATERFALL

The size of the source determines the size and force of the waterfall. Another factor affecting the waterfall is the height of the drop or descent. Finally, the waterfall is affected by the terrain in which it exists.

SMALL WATERFALL OVER VARYING DESCENTS
The water here is making several small falls where the land drops down. Because of this the water never falls far but instead rolls gently.

SMALL WATERFALL WITH LONG DESCENT
As a small waterfall makes a long descent it will separate and appear larger where it hits the water.

LARGE WATERFALL OVER VARYING DESCENTS
When a large waterfall goes over varying heights we see much more of it and it resembles rapids.

LARGE WATERFALL OVER DEEP DESCENT
When a large waterfall makes a deep descent it remains wide and creates a lot of spray when it reaches the bottom.

LIGHTING AFFECTS HOW WE SEE WATERFALLS

Light affects the values of a waterfall and the terrain around it. Therefore you must determine where the light comes from.

LIGHT FROM LEFT

When the light comes from the left it shines over the hills and creates more light on the right side of the waterfall.

LIGHT FROM RIGHT

When the light comes from the right it shines over the hills and creates more light on the right side of the waterfall.

THE ROLE OF VANTAGE POINT

Where we are standing (our vantage point) has a lot to do with how much of the waterfall we see.

LOOKING FROM ABOVE

When looking from above the waterfall we see most of the water in the river before it falls and after it has fallen. The descent itself is foreshortened.

LOOKING FROM BELOW

When looking from below the waterfall we see the actual descending water. We don't see any of the river that is feeding the waterfall.

STREAM SPILLING OVER ROCKS

As an artist you must learn how to depict the effects created when the river maneuvers and falls over rocks. As always, observation is key.

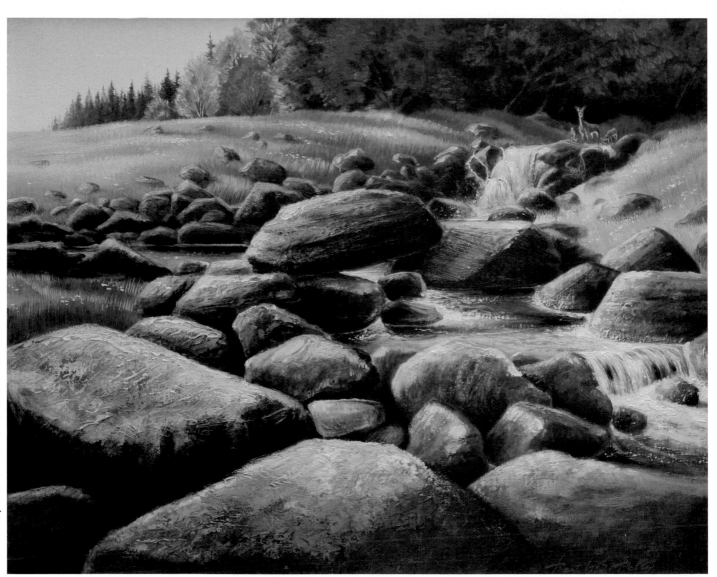

THE THAW | OIL, 16" × 20" (41CM × 51CM), PRIVATE COLLECTION

RUSHING SPRING WATER

In this painting of a small stream, the water is running rather quickly. It makes several falls as it flows over the rocks in its way. The vantage point suggests that you're seeing the river from above on the right lower corner and from straight on at the higher falls. The light is coming from the left, and, because it's late in the day, the sun is lower in the sky, creating more dark shadows.

It's late afternoon and the deer are beginning to move out of the woods and into the open meadow, stopping by the stream for a drink. The doe has her ears perked, listening and watching, while her twin fawns stand near.

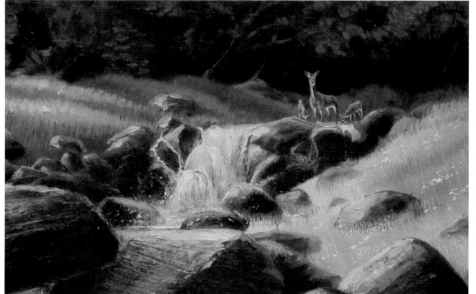

BACKGROUND WATERFALL

In this detail of the small waterfall, you can see how the water falls in steps on its left side, while the right side of the waterfall is almost straight. Since the light is coming from the left, the right area is more shaded. I used mostly white for the light area and painted the darker areas with several blues (mixing Prussian Blue with Alizarin Crimson makes a good blue for shadows). Also notice that the lighter deer are set against the dark of the woods, making them stand out.

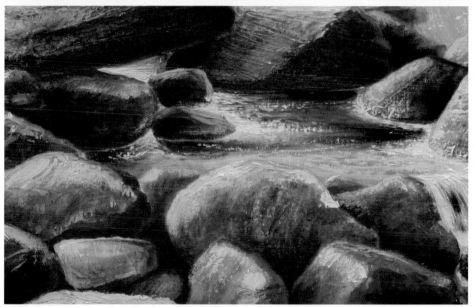

BELOW THE FALLS

The pool of water below the falls is an important element here. Notice the agitated water behind the rocks as the water flows around them. Since the water is flowing quickly when it encounters the rocks, it creates bubbles or white water. Notice a definite reflection of the rock in the water and the small light line where the water hits the rock.

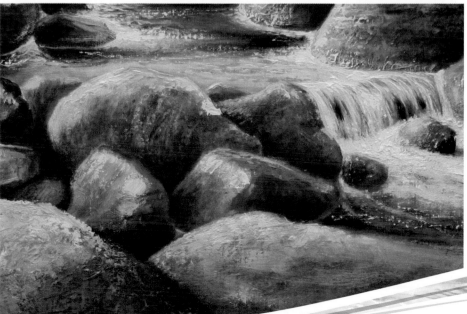

LOWER, FOREGROUND FALLS

The lower falls are seen from above and from the left. You can see the water as it flows over the rocks and flows downward to the right. I used white to create the foam at the bottom of the falls. After the painting dries, pick up some white paint with the tip of your finger and wipe it over the entire area around the lower falls to create spray. Do the same on the rocks just above the falls.

A **SERIES** OF **FALLS** IN ONE **RIVER**

When a wide river begins to fall, as it does here, a variety of effects take place. Many of the lessons you've already learned in this book are demonstrated here. The color, angle and direction of the water and the vantage point of the viewer are all easily observed in this painting.

PAINTING WATER ON LOCATION

The best way to paint any landscape is on location. You must paint quickly because of the time limit. The advantage is that you're forced to observe and paint the important elements, and can't get carried away with details.

Sometimes you can finish your painting later if you have a photograph. Or you can use a small painting you do on location as a sketch to make a larger painting, as I did here.

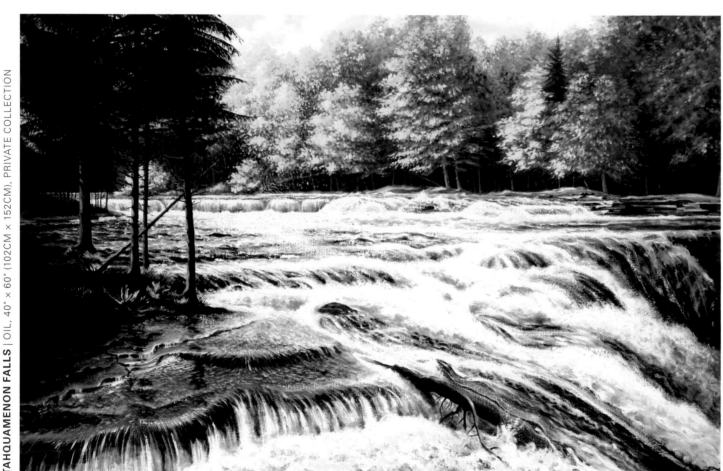

TAHQUAMENON FALLS | OIL, 40" × 60" (102CM × 152CM), PRIVATE COLLECTION

TWO FALLS IN ONE

The Tahquamenon Falls are located in the Upper Peninsula of Michigan. There are actually two falls, the Upper and the Lower, which are part of the Tahquamenon River system. The Upper Falls looks like a mini version of the Niagara Falls. The Lower Falls, seen here in my painting, is very wide and has a series of small drops in elevation. I did this painting of the Lower Falls on location. You can see me painting this on page 5. Later, at home, I did this larger, more detailed version based on that painting and my observations.

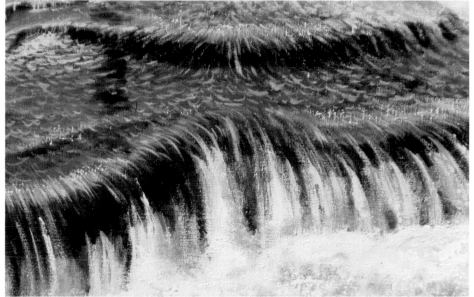

VIEW FROM ABOVE

Here you can see the shallow falls from above. Notice the small highlights created as the water falls over the rock ledge. Below this there's a dark area that is actually the rock beneath the transparent water. Create the falling water below by alternating white and dark stripes of Prussian Blue and Raw Umber. The cedar swamps where the river originates give the water a brownish tint. By adding Raw Sienna in the shadows I was able to get the right effect.

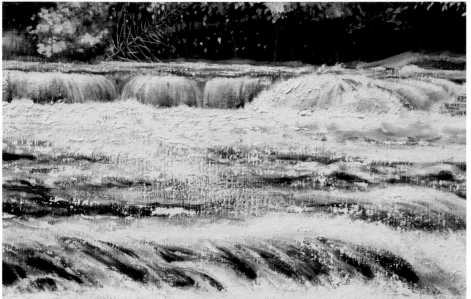

FALLS AT EYE LEVEL

Here you're looking at the farthest falls in the painting. Because the falls are at eye level, you see them straight on. For this area, I used a warmer color, Yellow Ochre with a touch of Raw Sienna. I painted the area below the falls where the water is agitated with almost pure white. As the water comes closer to the viewer, I added small wavelets using Prussian Blue and Raw Umber and a touch of Alizarin Crimson. Refer to page 74 if you need help painting wavelets.

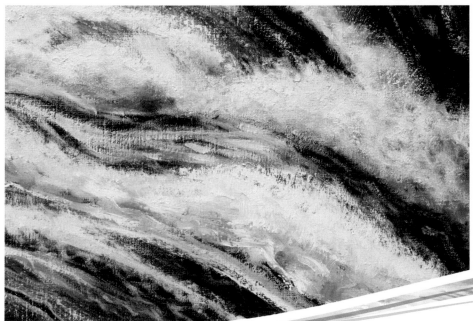

VERTICALLY ANGLED STROKES

The falls here are rushing downward and appear to be in confusion. The important thing to see here is the vertically angled strokes of the water on the right, with the white water foam between. I used Prussian Blue and Ultramarine Blue in the water. I toned it down where needed with some Raw Umber. You'll see that I used Raw Sienna again here and there in the water to simulate the brownish tint inherent in the water itself.

This is a smaller waterfall falling down a long descent I. Notice how it appears wider and thinner at the bottom. To paint this waterfall you'll need to make the water appear transparent, and you'll need to paint the water as it hits ledges and falls into the pool below.

TOWERING FALLS

While many waterfalls in the West are surrounded by rocks, the waterfalls in tropical areas are surrounded by volcanic rock and covered with rich foliage. The Hawaiian waterfall in this painting originates from a small stream and falls straight down a long descent. I chose to add some bright Hawaiian flowers in the foreground to add a little tropical ambience. The small figures in the pool below the falls give a sense of the waterfall's height.

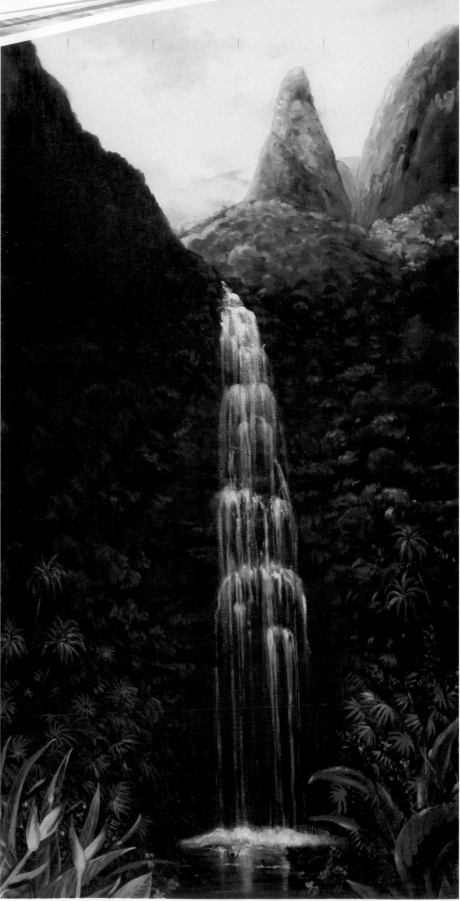

TROPICAL PARADISE | OIL, 48" × 24" (122CM × 61CM), PRIVATE COLLECTION

BEFORE THE PLUNGE

The water high above appears first as a small trickle and then forms a small triangle. At the top of its descent the water is almost purely white. Notice the straight line on the left and what appears to be steps on the right as the water descends.

FALLING WATER

Here the water appears almost transparent. Paint the background behind the waterfall before you paint the waterfall itself. Use various dark colors including Raw Umber, Ultramarine Blue, Alizarin Crimson and touches of green more toward the top. Let this dry before painting the waterfall. Then, using a blender brush with white paint and very little medium, hold the brush so that it's horizontal and push it onto the canvas at the point where the water hits the ledge. Then pull the brush downward to the next ledge. Finish this step by adding streaks of a medium-value blue using a small sable round brush.

REFLECTING POOL

As the water drops deeper it becomes bluer and the stripes of water become more separated. Use a sable round with Prussian Blue and Ultramarine Blue mixed with a little white to create the falling water. As the water hits the pool it foams up; paint this with almost pure white, allowing the colors to blend. Your strokes should be circular and your paint should have very little medium.

To paint the reflection of the waterfall in the pool below, first paint the pool itself and let it dry. Then paint vertical lines of white paint with a dry brush to simulate this reflection. Finally, add flowers and plants in the foreground.

LARGE FALLS

Large falls can be difficult to paint. To succeed, combine techniques for painting rivers and light reflections with techniques of painting falling water and mist.

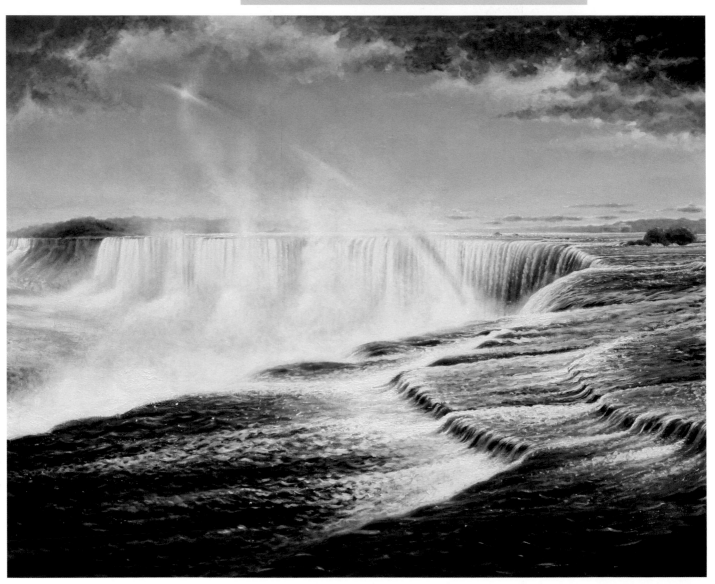

NIAGARA FALLS | OIL, 40" × 50" (102CM × 127CM), PRIVATE COLLECTION

NIAGARA FALLS

These falls have been painted many times, and often from this very angle because there are not really many spots from which to paint. From the observation platform you can see the water below you just before it tumbles over the edge, but you can also see the horseshoe configuration as it curves around. Finally, you can see the distant American Falls falling onto large rocks. This is a special and unique experience.

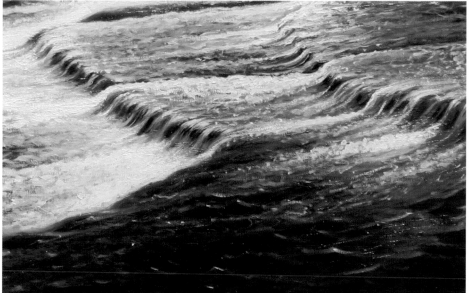

RIVER WAVELETS

Notice that the river above the falls, and at the right and front of it, is painted like any other river. Notice also the small wavelets in the foreground, done using the techniques on page 74. To create the darks in the water, I used a lot of Viridian with various blues (mostly Prussian Blue and some Ultramarine Blue) and touches of Alizarin Crimson and Raw Sienna here and there. I used the same colors with white to create the highlights. Notice how the wavelets get larger as they come closer to you.

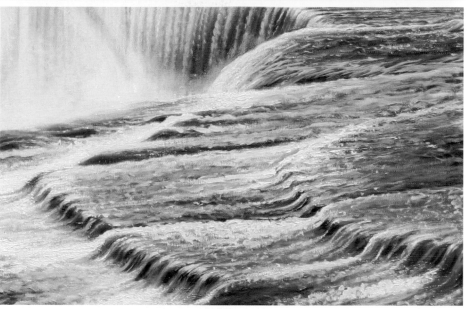

LIGHT ON WATER

Here you can see the water as it goes over some of the rocky ledges above the falls. Notice the light hitting the top of the water. Here, I used straight white. The shadow and the rock beneath are dark, so paint them with a combination of Burnt Sienna, Viridian and Alizarin Crimson. The transition area, which comes next, is painted with Cerulean Blue, Viridian and just enough white to make it the correct value. Of course, as the water levels out it becomes white water and should be painted white.

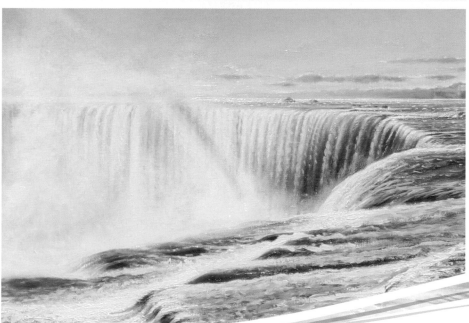

THE HORSESHOE

At the horseshoe, the water is white where the sun hits the edge just before it falls and it gets darker as it falls deeper into the gorge. I used Viridian, Prussian Blue and Ultramarine Blue with white to paint this area. Always use up-and-down choppy strokes to suggest falling water. There's a lot of mist at the bottom of the falls. It rises quite high and will obscure the falls at the bottom. I waited until the paint was dry and used a drybrush technique (see *Glossary* on page 139) over the top of the area to create this effect.

PAINTING **MIST**

In this painting we observe the waterfall from far away. We can see the falls as it hits the many boulders hidden at the bottom and creates mist. On the next page you'll learn how I painted the mist, the light and the pool below.

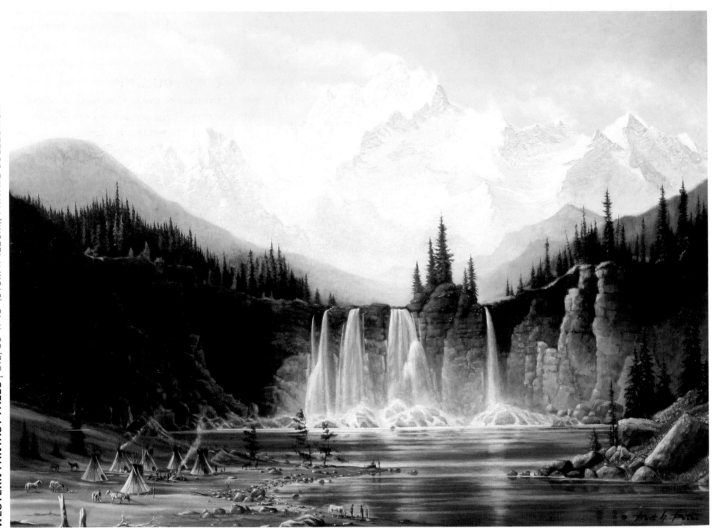

WESTERN FANTASY FALLS | OIL, 36" × 48" (91CM × 122CM), PRIVATE COLLECTION

SEVERAL SOURCES, ONE WATERFALL

In the mid 1800s there was a group of artists who called themselves the Hudson River School. This was a time when the western U.S. was being discovered, and these artists portrayed the pristine West of the time. It's one of my favorite periods and here I tried to re-create a scene they may have painted.

The waterfall is unusual in that it has more than one fall coming from several rivers. As in several of my other paintings, I painted a Native American camp. As with the painting of Niagara Falls, I worked on this for many years.

LIGHT ON THE ROCKS

Because the light is coming from the left, I used straight white on both the top and the left side of the waterfall. At several points you can see where the water hits rocks and you see another layer of white. The shaded area was painted using Viridian and white.

HIDDEN BOULDERS

At the base of this waterfall there are many boulders. These are barely visible beneath the water. I used the same colors as for the rocks—Burnt Sienna, Alizarin Crimson and Prussian Blue—but with more white to give just a hint of the rocks beneath the water. The top of the boulders are white where the water is hitting them. After this was dry I used my finger with some white (wipe most of it off first) and rubbed it over the area to simulate the mist.

THE POOL

Paint the pool with horizontal stripes using the same colors as for the surrounding rocks and water. Create the reflection of the waterfall with straight white. Notice the reflection of the rocks. Paint these reflections as a mirror image of the rock with a small white line between.

Waterfall in Rocky Terrain

This waterfall looks like three waterfalls. The terrain is rocky and some of the large boulders have divided up the stream. The vantage point of this waterfall is from below, so we don't see the river before it begins the falls. The bright sunlight lights up the scene on top and to the right (the direction the light is coming from is from above and to the left). The shadow from the rocks on the left casts a shadow over the lower part of the waterfall. The colors are deeper because everything in the gorge is wet. Remember, water on any object will make it appear several shades darker.

MATERIALS LIST

ACRYLICS
Payne's Gray, Titanium White

OILS
Burnt Sienna, Cerulean Blue, Payne's Gray, Prussian Blue, Raw Umber, Titanium White, Ultramarine Blue, Viridian, Yellow Ochre

SURFACE
Primed canvas

BRUSHES
Nos. 2, 4, 6 and 8 hog bristle brights, no. 2 sable round

OTHER
Clean rag, painting knife, pencil, turpentine oil medium

WATERFALL WITH ROCKS | OIL, 24" × 30" (61CM × 76CM), PRIVATE COLLECTION

1 SKETCH THE **PAINTING** AND ADD THE **SKY** AND **BOTTOM WATER**

Draw the composition with a pencil, then go over the lines with a light-gray acrylic (Payne's Gray and Titanium White). Paint the fir trees on the top with this mixture. This step will ensure that you don't lose your sketch as you paint.

Now paint a pale-blue sky directly over the trees with a light-blue mixture of Cerulean Blue, Ultramarine Blue and lots of Titanium White, using a no. 8 bright. Using the same mixture but with less Titanium White, paint the water at the bottom of the picture.

2 PAINT THE **ROCKS**

Using a no. 6 bright, paint the rocks with Burnt Sienna, Raw Umber and Titanium White. Establish the darks and lights and use wide, bold strokes. Don't try to follow my painting exactly, but rather create your own boulders as you go. For the waterfall use Titanium White with a bit of the light-blue sky mixture from Step 1 and a bit of the colors used for the rocks. Use a no. 4 bright to apply quick, vertical strokes to the area.

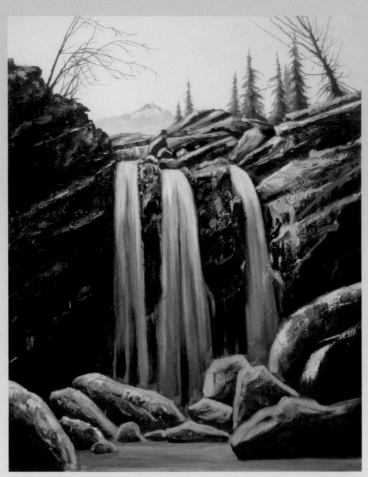

3 CREATE **TEXTURE** ON THE **ROCKS**

Begin using the painting knife to create texture on the rocks with Raw Umber and Prussian Blue. Don't worry about the finished rocks. You'll be going over these several times as you paint. The more you go over the rocks with the painting knife, the more texture you will get and the better the effect will be. (See chapter 7 for more information on how to paint with the knife.) Punch out the darks and lights, remembering to keep the left side of the rocks darker than the right. Put more Titanium White on the top of the waterfalls.

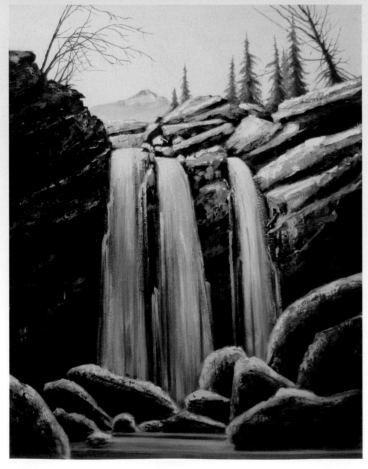

4 BEGIN **WORKING** ON THE **WATER**

Begin working on the water by adding more Cerulean Blue and Prussian Blue to the lower area on the falls. Drag your no. 4 bright over the paint using streaks of Burnt Sienna and Yellow Ochre. Make sure to keep the very top of the waterfall white. Let the painting dry for a few days before starting the next step.

Work some more on the deep walls on the right, using Yellow Ochre, Raw Umber and Titanium White to make the rocks light and sunny with the painting knife.

5 CREATE THE **SPRAY**

Use a no. 8 bright filled with sloppy Titanium White that's been thinned with turpentine oil medium. Run your finger or thumb across the bristles and direct the spray where you want it. Practice this several times before trying it on the painting. If you create too much spray, carefully dab it off with a clean rag.

TIP FOR CREATING SPRAY

To make spray, choose a hog bristle bright brush that fits the size of the area to be sprayed. Make sure the consistency of your paint is runny and move your finger across the bristles over the area you want the spray to be. This technique can be used for any spray, including waterfall, surf, snow or rain.

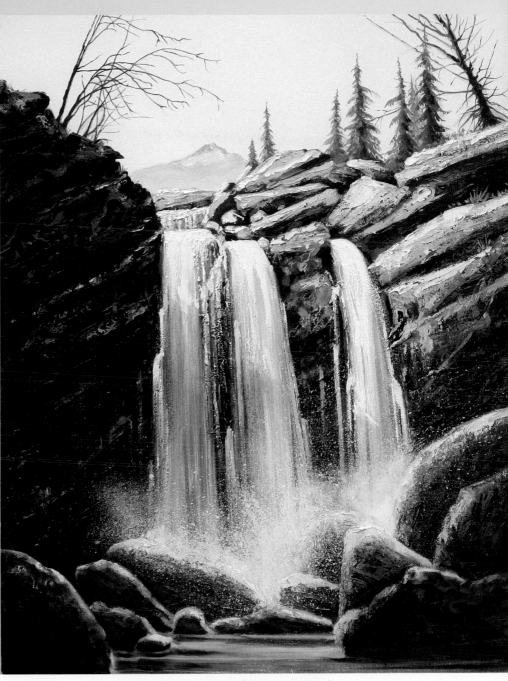

6 CREATE **DARKER AREAS**

Now use a no. 2 bright with the Titanium White, Cerulean Blue and Prussian Blue mixture to create the dark areas below the spray and the darker areas of shadow on the falls. Let the painting dry or rest for a few days before going further.

7 REFINE THE **ROCKS**

Be sure the painting is dry before adding more texture. Otherwise, the paint will mix and your texture may not be as interesting. Scrape over the rocks using the painting knife with various colors. I used a green mixture of Viridian, Yellow Ochre and Raw Umber to simulate moss. I also used the colors used for the water below the falls (from Step 1). This gives the painting interest and unity.

8 ADD **MORE TEXTURE**

With your painting knife, make the texture of the top rocks much lighter using mainly Titanium White with some warm Yellow Ochre and a little Burnt Sienna. Lay your painting knife on its side and run it across the top of the rocks.

THE COMPLETE GUIDE TO **PAINTING WATER**

DETAIL OF TREES

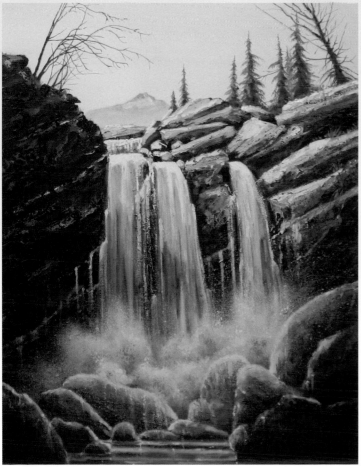

9 ADD **FINISHING DETAILS**

Using a no. 2 sable round, add the details of the trees. To create the deciduous trees, let the brush do the work. Hold the brush like a very old man who has the shakes. This gives the branches a very irregular shape as they have in nature. Be sure to pull the branches away from the trunk. Use Raw Umber for the branches of the bare trees and use some blue (Payne's Gray, Titanium White and Cerulean Blue) for the fir trees. Add some green foliage wherever you feel it's appropriate.

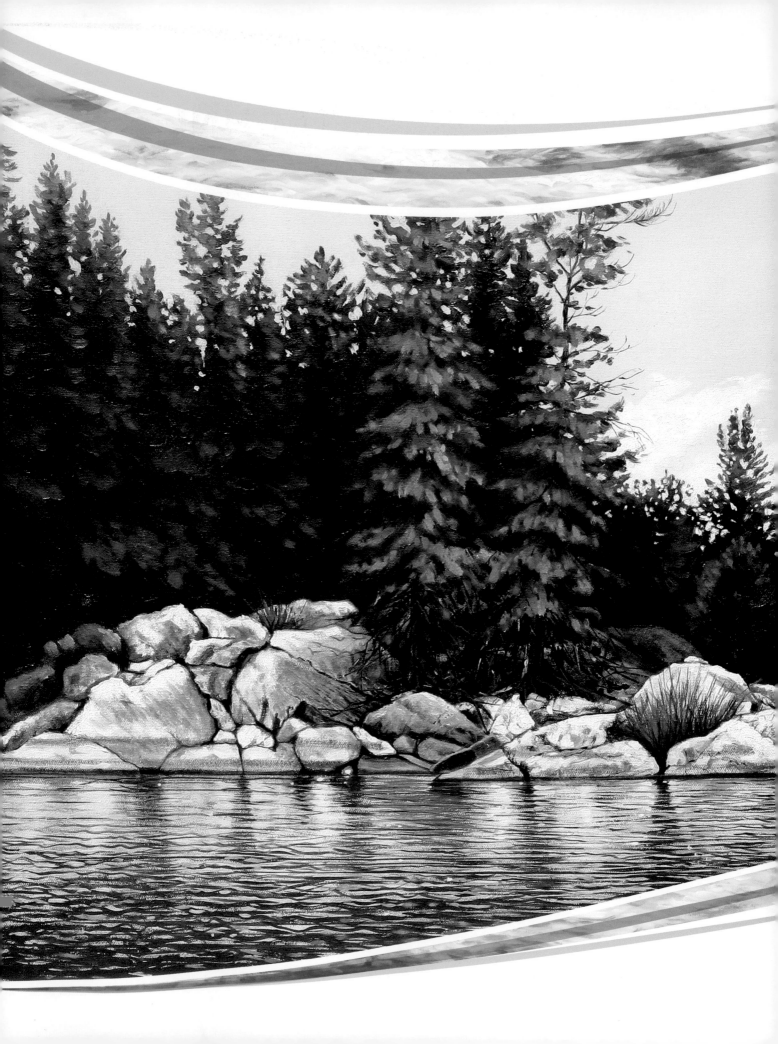

SPECIAL **TECHNIQUES**

I added this chapter to address essential aspects of water and how to paint it that didn't fit elsewhere in the book. I'd be remiss if I didn't talk about the smallest droplet of water on a leaf, or the water in containers or glasses. I also feel compelled to say more about the things that often surround water, such as rocks and grass.

No matter what problem we're dealing with, we must remember the basic rules of how water acts under different circumstances. A fountain acts much like a waterfall. Water in a container acts much like a pool. You'll not be at a loss if you just go back to the basic facts. Refer to chapter two on basic facts as often as needed to reinforce the principles you've already learned.

I also want to leave you with special techniques that will help you as you grow in your ability as a painter. I've spent many years painting, and I've learned much in that time. I've accumulated a myriad of tricks and techniques, some of which are great time-savers. Back when I was in school, my teachers believed in keeping and guarding certain "secrets" for themselves. Today, many artists still practice this habit. But I believe I can never give enough to my students. No trade secret is worth keeping if it deprives an artist (or art itself) of its benefit. Therefore, I'm giving my secrets to you, my friend, as my legacy. I hope you'll take the time to try them and perfect them. In the process you may even come up with your own tricks. But please make it a habit to be generous to other artists and to always share what you know.

ENTRY TO PORTAGE COVE | OIL, 24" × 30" (61CM × 76CM), PRIVATE COLLECTION

Water Droplet

Water in the form of droplets often falls as rain or develops on a leaf as a dewdrop. A tear on the cheek of a child can also be seen as a droplet of water. When these are painted with skill they leave the viewer in awe.

A water droplet's shape is usually round or nearly round. The underside of the droplet is flat and conforms to the shape of the object it's on. Because water is clear you see the color of the object beneath. Sometimes you can even see images reflected in the droplet. If you take a picture of a water droplet, you might find that the picture shows both the drop and you photographing it.

MATERIALS LIST

OILS
Cadmium Yellow Light, Raw Umber, Titanium White, Ultramarine Blue

SURFACE
Primed canvas

BRUSHES
No. 4 angular Taklon, no. 0 sable round

OTHER
Turpentine oil medium

1 PAINT THE **LEAF**

The first step in painting a water droplet is to paint the object on which it sits. In this case, the droplet is on a leaf. Use a mixture of Ultramarine Blue, Raw Umber and Cadmium Yellow to fill in your leaf shape with a no. 4 angular Taklon. Put in the leaf's texture and lines using lighter and darker shades of the leaf mixture. Add Titanium White and Cadmium Yellow Light to your green mixture to create lights. Add more Ultramarine Blue and Raw Umber to create your darks. When you're satisfied with the leaf, let the paint dry, then begin painting the droplet.

The water acts as a magnifier, making the area under the droplet lighter than the rest of the leaf. So for this step use a lighter shade of the leaf color. Use a no. 0 round to paint a circle on the leaf. Fill in the circle with the lighter shade of green.

2 ADD **SHADING**

Surround your circle with a dark halo for the shadow created by the droplet. Use your no. 0 round with a mixture of Raw Umber and Ultramarine Blue. Wash your brush thoroughly when you're finished.

3 ADD THE **HIGHLIGHT**

Create a lighter green by adding more Cadmium Yellow Light to the mixture from Step 1. Use this to indicate the light shining into the droplet along the bottom right. Using the no. 0 round, pick up some Titanium White paint and place a dot for the highlight. Clean your brush again. Put a very small shadow on the underside of the highlight using the darker greens from Step 1. It should be barely noticeable. Voila!

LIQUID IN CONTAINERS

We see containers of water and other liquids every day. That first cup of coffee, which contains mostly water, gets us going every morning. The vase of flowers on the table is full of water. Let's not forget the glass of wine sipped over dinner. Now you'll learn how to paint these familiar sights.

TRANSPARENCY CREATES A VISIBLE BACKGROUND
Since the glass and the liquid are both transparent, the background will be visible through both.

PAINTING THE WINE BOTTLE

Here you can see the green wine bottle less than half full of red wine. The first concern is to draw the bottle correctly. Notice that the bottom of the bottle is concave and appears very dark. If you look at this area through the wall of the bottle, you'll notice that on the top of this bump is a very bright light. Create this light by picking up some pure Titanium White with a no. 2 sable round and simply dotting the paint where the highlight should appear.

Create the red color of the wine with Alizarin Crimson and the green color of the bottle with a mixture of Prussian Blue and Cadmium Yellow Light. There's a very bright light coming through the bottle on either side. I used Cadmium Red with a little Alizarin Crimson to get this effect. Note the white lines of reflection on the sides of the bottle. This is where the wine comes in contact with the bottle and relies on the same principle of water coming in contact with rock in a stream.

PAINTING THE GLASS OF WINE

Here's a close-up of the white wine in a clear glass. If you look closely, you'll see the wine is really the color of light amber. The glass itself is transparent and we see very little of the liquid except its tint. Notice the line where the top of the wine's surface meets the glass. This suggests evidence of the existence of liquid. Because the vantage point is from above, you see this line as an oval shape. This oval must be shaded perfectly. If you can't draw it freehand, use a template from an art store.

The top surface of the liquid acts like a mirror and reflects what is above it, as you learned in chapter two. Finally, because both the glass and the liquid are transparent, any color behind them will show through. The green drapery behind can be seen through the glass and the liquid, so use these colors as you paint the glass of wine.

Outdoor Fountain

DEMONSTRATION | ACRYLIC

Humanity's fascination with water culminated at some point in the invention of the fountain. Water fountains grace the center of many major cities throughout the world. It's a manufactured version of a waterfall, so in many ways, water from a fountain acts like a natural waterfall.

Like a waterfall, the water in the fountain falls. It's first forced up a casing and ejected under high pressure. As it flies through the air the water separates into millions of droplets and falls back to the ground or water basin. What must be observed here is the curvature of the water's stream, where velocity diminishes and gravity asserts itself. As the viewer, your position relative to the wind is also important.

MATERIALS LIST

ACRYLICS
Alizarin Crimson, Cadmium Yellow Light, Cerulean Blue, Cobalt Blue, Ivory Black, Payne's Gray, Raw Umber, Titanium White, Viridian, Yellow Ochre

SURFACE
Primed canvas

BRUSHES
Nos. 2 and 4 hog bristle brights, no. 2 sable round

OTHER
Paper towels, pencil, spray fixative

CHICAGO'S BUCKINGHAM MEMORIAL FOUNTAIN | ACRYLIC, 20" x 24" (51CM x 61CM), PRIVATE COLLECTION

1 SKETCH THE COMPOSITION

Sketch the fountain and surrounding buildings with pencil. When you're satisfied with your sketch, spray it with fixative. When this is dry, go over the lines lightly with a blue made of Payne's Gray and Titanium White. This will ensure that you don't lose your sketch while painting. If you make a mistake, you can wipe off your paint with a paper towel and your sketch will remain.

2 PAINT THE SKY AND TREES

With a no. 2 bright, begin painting the right side of the sky with a pale-yellow mixture of Titanium White with a little Cadmium Yellow Light and Yellow Ochre. For the darker area in the sky, mix Cerulean Blue with some Alizarin Crimson to create a medium gray. Vary the color using more Cerulean Blue in some areas and more Alizarin Crimson in others. This will give you a dramatic sky. Paint the dark areas of the trees behind the fountain with a no. 2 bright and Cadmium Yellow Light mixed with Ivory Black.

3 PAINT THE **BUILDINGS**

To make the buildings in the background recede, add white to the colors used to paint them. Paint the buildings in shadow using a no. 2 bright and mixtures of Cobalt Blue and Titanium White, and Raw Umber and Titanium White. For the buildings getting sunlight, use Titanium White with a touch of Cadmium Yellow Light on the right side. Remember, you only want to give the "impression" of buildings. Use the no. 2 bright and Raw Umber with a small amount of Titanium White to begin the foundation of the fountain.

4 CREATE THE **FOUNTAIN STRUCTURE**

With a no. 2 bright, add a mixture of Ivory Black and Cadmium Yellow Light to the background trees. Add some green to the foreground using the same mixture with more Cadmium Yellow Light. Use more Raw Umber for the fountain's foundation. Let this dry before going to the next step.

5 COMPLETE THE **FOUNTAIN** AND ADD THE **WATER**

Use the Raw Umber used for the center foundation to paint an enclosure around the fountain with a no. 2 bright. Paint the inside using Titanium White and put two sculptures on either side of the fountain using Viridian and Titanium White. Paint the sculptures loosely with a no. 2 round.

Now add the water to the fountain, starting at the fountain's center and working outward. Using a no. 2 bright and Titanium White, draw the brush up from the fountain's center, and when you reach the spot where the water will drop, pull the brush down in a curving motion. The center spire of water should be highest, with the spires on the side successively lower. Now using a no. 2 bright, pull some Titanium White from the center to the sculptures you already painted. Add a touch of Cadmium Yellow Light to the Titanium White for the water in the fountain, since the water is reflecting the sky.

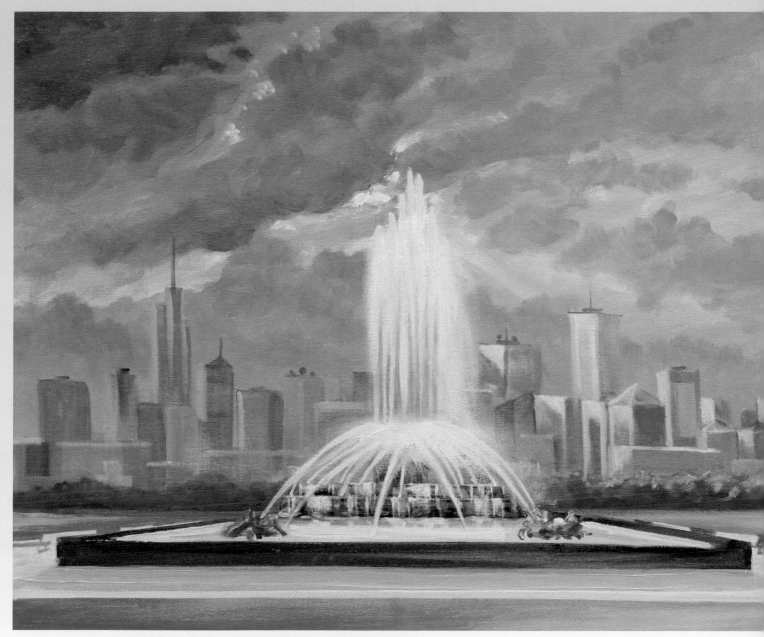

6 ADD THE **FINISHING TOUCHES**

Paint some water dripping down the fountain basin using pure Titanium White and a no. 2 round. Add some Cobalt Blue to your Titanium White to add dimension to the water. Use a no. 4 bright to heighten and enhance the fountain. Finally, paint a gray cement area around the fountain using Titanium White, Payne's Gray and a no. 4 bright.

PAINTING WITH A MAHLSTICK

A necessary technique for painting water, especially oceans, is the ability to make a straight horizon line. As you've learned, water is always level, and therefore it's important that the line you use to depict the area where the water and the sky meet is level. Using a mahlstick is imperative here, because it will help you steady your hand and allow you to draw a straight line. A mahlstick can be made of wood, metal or fiberglass. You can purchase one at an art store, but I prefer to make my own.

MAKE YOUR OWN MAHLSTICK

A mahlstick is simply a dowel, usually made of wood. It should be $^3/_8$ inch (10mm) in diameter and between 18 inches (46cm) and 4 feet (1m) long. The most comfortable range is between 20 and 30 inches (51cm–76cm). On one end of the dowel, create a soft ball about 1 inch (25mm) in diameter. You can make the ball with lots of masking tape, simply wrapping it around the dowel tightly. I also like to wrap two layers of a soft, white cotton cloth tightly around it. (A discarded T-shirt works very well.) Then I tie a nylon line around it as close to the ball as possible and snip off the excess.

CREATING A PERFECTLY STRAIGHT LINE
Here you can see me using a mahlstick on a painting. Notice how I hold my hand and the position of my fingers on the mahlstick.

USING A **MAHLSTICK** TO MAKE **STRAIGHT LINES**

Perhaps the most important use of a mahl-stick is to make straight lines. These lines could be used for anything from a mast on a sailboat to the horizon line between the water and the sky.

Using the correct brush and the paint consistency is critical. You can generally use any brush, but for fine lines (like the lines on a sailboat) use a round brush with a perfect tip. Oils should be thinned down with turpentine and Liquin till it has the consistency of cream. Have enough thinned paint on hand to do the entire line, but first try a test line on another surface. When everything is right, you can:

1. Pick up the paint with your brush, holding it like you would use a pen or pencil.
2. Place the ball of the mahlstick on the edge of the canvas and line it up with the line you want to make. Make sure the mahlstick is parallel to the canvas or board by holding it with the finger of your nonpainting hand underneath the stick end that's opposite the ball. If you don't keep the distance between the canvas and the mahlstick dowel parallel, the result will be lines that get thicker where the mahlstick is closer to the canvas and vise versa.
3. Adjust the distance from the brush tip on the canvas to the contact point on the mahlstick. There are two points of contact with the mahlstick. The middle finger rests on the mahlstick, and the ferrule (metal part of the brush) is in contact with the mahlstick as shown on page 132. These stay in contact through the entire process.
4. Pull the brush toward you, making sure that the ferrule of the brush stays in contact with the dowel on the mahl-stick as your middle finger glides along the dowel.

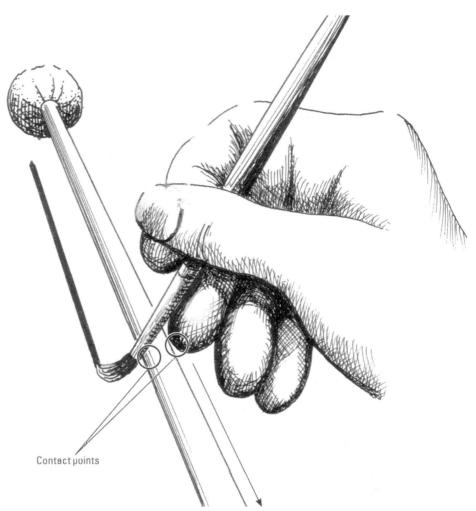

Contact points

USING A MAHLSTICK TO STEADY YOUR HAND

Use a mahlstick to support your painting hand when you need to paint detail on a wet painting. Holding the stick with your free hand, simply put the end of the ball on a dry spot, the edge of the painting, or on your easel. Then you can rest your painting hand on the stick. This method requires very little practice.

PRACTICE MAKES PERFECT

Practice working with the mahlstick using thin paint on any type of surface. When you've acquired enough skill to use the mahlstick comfortably you can use it on your painting.

GLAZES

A *glaze* can be any transparent color applied over another color that is already dry. This modifies the original color over which the glaze is applied.

Glazes are used in all painting, but they're especially important when painting water. Water is transparent, and in some cases, using a glaze is the answer to a painting problem. If you're painting a scene where you're looking down into a stream from above and seeing the objects below, using a glaze is appropriate. A glaze can be used to paint liquids in vessels, and to capture the brilliance of a sunset. A glaze can also depict the color that comes through the arch of a breaker.

Not all commercially available colors are transparent or suitable for glazes. Colors not suitable for glazing include those that are opaque and can't be seen through. In chapter one we discussed opaque and transparent colors. Check the list on page 12 for colors that are appropriate for glazing.

To glaze with oils, thin the paint with a standard medium or a mixture of linseed oil or Liquin and a little turpentine; just use water if you're working in watercolor or acrylic. Adding too much medium won't make a suitable glaze because the paint will run, especially if the painting is sitting upright.

Your glaze should be applied over a dry underpainting or the glaze will mix with the wet paint, defeating the intended purpose.

It's also best to glaze over a lighter underpainting. Colors applied over a white or light underpainting appear much brighter than those applied over a dark underpainting.

As stated, glazing is useful for painting brilliant sunsets. I use a series of glazes, beginning with white, over which I apply yellow, and finally orange and red glazing. Each step must dry thoroughly before you put on the next glaze.

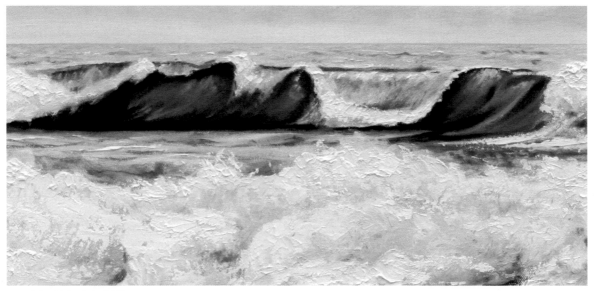

LAKE MICHIGAN SURF | OIL, 24" × 30" (61CM × 76CM), PRIVATE COLLECTION

GLAZES ON A WAVE
One way to capture the sun through a wave is to use a glaze. In this case, I painted white in the area where the sun came through. After this area was completely dry, I brushed a glaze of Cadmium Yellow Light thinned down with turpentine over it.

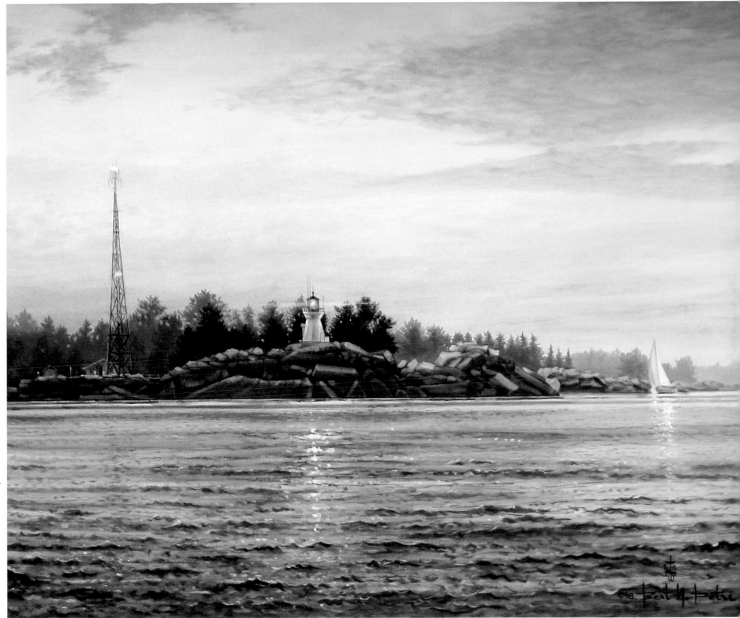

GLAZES ON THE SKY

I used a series of glazes for the evening sky in this painting. Once the basecoat was completely dry, I brushed on a light glaze of Cadmium Yellow Light. Once that was dry, I added another glaze of Cadmium Red Light. I used these same glazes in the water for the sky's reflection.

Using a Painting Knife to Create Rocks

DEMONSTRATION | OIL

Rocks and cliffs are often a part of water scenes. Using a painting knife is the most suitable tool for that purpose.

When using a painting knife to paint rocks, start with an outline, then underpaint the rocks. Use the painting knife to create the shadows, highlights and texture of the rocks.

Be sure to pick up a generous amount of paint with the knife and lay the paint on the canvas. Apply several colors of paint, only lightly mixed, to increase the textural effect.

As always, practice is important. Allow yourself extensive trial-and-error practice before attempting to use the painting knife on an otherwise well-executed painting.

MATERIALS LIST

OILS
Alizarin Crimson, Payne's Gray (optional), Prussian Blue, Raw Umber, Titanium White

SURFACE
Primed canvas

BRUSHES
No. 4 hog bristle bright

OTHER
Painting knife, paper towel or rag

1 APPLY THE **BASECOAT**

Mix some gray using Prussian Blue, Alizarin Crimson, Raw Umber and Titanium White. If your proportions are correct you'll achieve a nice gray color. If you have trouble, you can always try Payne's Gray and Titanium White. With this mixture and a no. 4 bright, paint the basic shape of your rock. Keep the bottom flat and make the top rounded.

PALETTE KNIVES VS. PAINTING KNIVES

A painting knife is different from a palette knife. The purpose of a palette knife is to mix paint on the palette, while a painting knife is for painting. I know artists who use them interchangeably, but I prefer not to.

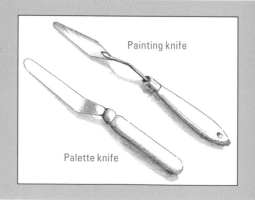

Painting knife

Palette knife

2 ADD **SHADOWS** WITH THE **PAINTING KNIFE**

Mix a darker version of your gray using less Titanium White. Scrape off a good amount of paint from your palette with your painting knife. Use this mixture to lay in the darker area on the bottom of the rocks. Continue to add shading and texture with your painting knife using several mixtures of gray.

3 CREATE **HIGHLIGHTS**

Wipe off your painting knife with a paper towel or rag, and pick up some Titanium White from your palette with your clean knife. Make sure you have a "ledge" of paint along the entire knife. Lay this on the top of the rock and gently draw the paint over the rock to create highlights. Don't overwork the paint or you'll lose the highlight because the paint will blend together.

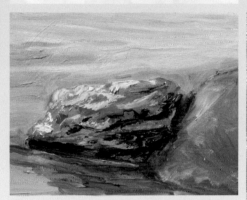

4 ADD THE **BACKGROUND**

Paint another rock to the left using your no. 4 bright. Paint the background water with Prussian Blue and touches of Raw Umber and Titanium White. Use some of the gray mixture to add reflections in the area below the rock.

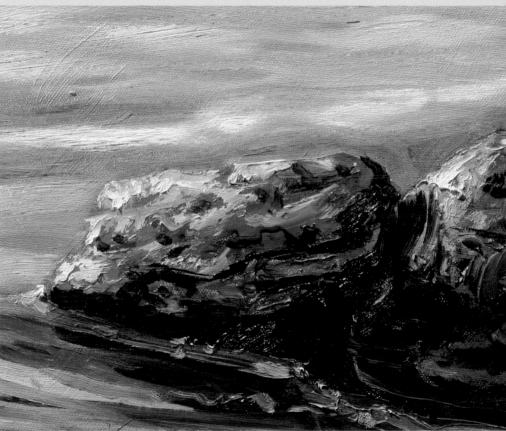

5 ADD THE **FINISHING TOUCHES**

Paint the shading and highlights on the rock just as you did in Steps 2 and 3. Add some Titanium White highlights to the water. Finally, add streaks of dark in the reflection, followed by a quick stroke of Prussian Blue between the reflection and the rock.

METHODS FOR PAINTING GRASS

Beach and dune grasses are common features of seascapes. There are two methods I use to achieve realistic grasses. The first takes time and patience and is probably not for everyone. The second is more a "trick of the trade." Both methods can give very convincing results when executed correctly.

USING A LINER BRUSH

Choose a liner brush that's in good shape, with no loose hairs. Begin by mixing the desired paint color and adding medium until the paint has a soupy consistency. Next, lay the liner brush in the soupy mixture of paint and roll it. The point is to fill the liner with paint from the tip to the ferrule. To create grass, drag the liner from what would be the base of the blade of grass to the tip in a quick motion. Do this with a variety of values and colors, working one over the other until you're satisfied.

USING A HAIR COMB AND OLD BRUSH

Using a hair comb is an easier way to make grass. This technique works best when done with water-soluble paints.

Underpaint the area where you want to create grass, then mix your paint to a very thin consistency. Use a fine-toothed hair comb and a slightly worn flat of almost any size, though I prefer a ¾-inch (19mm) flat. Fill the brush with thinned paint, but do not overload it. Lay the brush flat at the edge of the puddle of paint on your palette. Then push the end of the comb through the hair, close to the ferrule, and carefully pull the hair through the comb, separating the hair into little bundles. Use this brush to paint the grassy area. Over this, use a round brush to add the final texture, color, shadow and highlights.

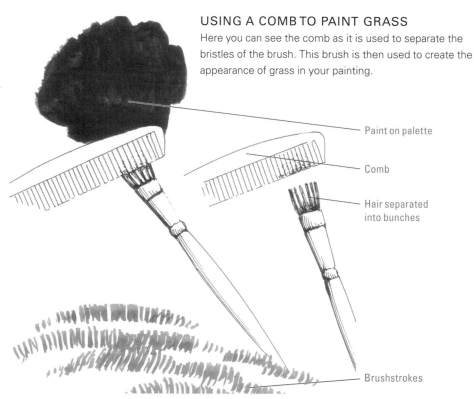

USING A COMB TO PAINT GRASS
Here you can see the comb as it is used to separate the bristles of the brush. This brush is then used to create the appearance of grass in your painting.

Paint on palette

Comb

Hair separated into bunches

Brushstrokes

GRASS PAINTING WITH A LINER
Here the grasses are drawn across the painting in a sweeping movement working from the bottom to the tip of each blade with a liner brush.

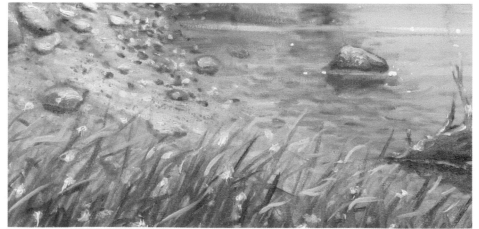

GLOSSARY

A

Aerial perspective—*the illusion of depth or spatial relationships created by the use of color.*

B

Beaufort scale—*a scale on which successive ranges of wind velocities are assigned code numbers from 0 to 12.*

Breaker—*a large wave that falls onto itself.*

C

Complementary Colors—*opposite colors on the color wheel. Yellow is the complement of Purple. Red is the complement of Green. Orange is the complement of Blue. Complements placed next to each other will enhance both colors. Complements mixed together will create a neutral.*

Composition—*the arrangement of shapes and objects into a whole work of art.*

Cool colors—*colors on the color wheel that evoke a cool feeling. Blues, blue-greens and blue-purples are considered cool. They tend to recede.*

D

Diffraction—*the bending or shattering of a beam of light.*

Drybrush—*painting with a brush using no medium.*

E

Eye level—*the imaginary level or plane extending in a horizontal line from the eye outward to infinity; not to be confused with the horizon.*

F

Ferrule—*the tubular metal part of the brush that encloses the bristles.*

Fetch—*the distance traveled by the wave across open water; determines to a great degree the height of the waves.*

G

Glaze—*the technique of thinning paint to a transparent color and painting in layers.*

H

Horizon—*the apparent junction of the earth and sky.*

Horizontal—*that which is parallel to the horizon; the opposite of vertical; side to side.*

Hue—*a specific color. Red, yellow and blue are all hues.*

I

Intensity—*the purity of a color.*

L

Luminosity—*the quality of being bright or shining.*

M

Mahlstick—*a tool used by artists to make straight lines and to steady the hand.*

Medium—*an additive to paint to make it flow and spread easier, or to shorten drying time.*

O

Opacity—*the quality of not allowing the light to pass through.*

P

Perspective—*the art of depicting landscapes and three-dimensional objects on a flat surface in such a way as to express dimension and spatial relationships.*

R

Reflection image—*that part or parts of objects above the water's surface that reflects a mirrorlike and upside-down image on the water's surface.*

Reflection loss—*the part of the landscape that is not seen in the reflection and is determined by the vantage point of the viewer.*

S

Shade—*the darkening value of a color.*

T

Tint—*the lightening value of a color.*

Transparent—*allowing light to pass through so objects below it can be seen.*

V

Value—*the lightness or darkness of a color.*

Vanishing point—*in perspective, that point towards which receding parallel lines appear to converge.*

Vantage point—*the position from which one views an object or landscape.*

Vertical—*that which is perpendicular to the horizon. The opposite of horizontal; up and down.*

W

Warm colors—*colors that evoke a feeling of warmth. Red and yellow are considered warm colors and tend to come toward the viewer instead of recede.*

Wave period—*the interval of time between the passage of two successive wave crests or troughs.*

Wash—*paint thinned down with a substantial amount of water; usually refers to watercolor.*

Wet-in-wet—*the method of painting where the paint remains wet and is not allowed to dry between steps.*

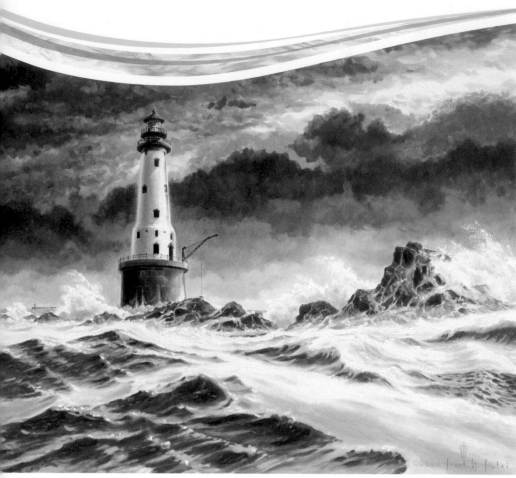

ROCK OF AGES | OIL, 30" × 35" (76CM × 89CM), PRIVATE COLLECTION

In the previous pages I've endeavored to introduce you to the art of understanding and painting water in all its various forms. I've tried to leave you with as much information as I can, but now it's up to you to use it. Don't be discouraged if you weren't able to absorb it all at once. You'll probably need to re-read and refer to the book often before it will be set in your mind. Remember also what I've repeated so often in this book—that observation and practice really is key to your success.

Knowing about water and being able to paint it isn't enough to make you an artist. Anyone who seriously wants to become a good artist has to do more than "put in his time." To be an artist means dedicating yourself to your work. Every morning when I leave the breakfast table I go to work. Granted, it's only a few steps from the table, but in my mind, I've left for my job, which is to be the very best artist I know how to be. I work all day and sometimes into the night. I'm not satisfied until I've achieved what I set out to do. My hope is that you, too, will begin to think of your art in this way and feel the great satisfaction of being an artist.

Every artist has his or her own style and technique. I hope that you'll be able to glean some useful techniques from this book. In the end, however, you must somehow find a style that reflects you. When you copy others' work, always try to find something in it that can become a part of your own style. Each artist has their own vision and it's your job to find yours. You find it by watching, listening, being involved, and mostly by just working your heart out.

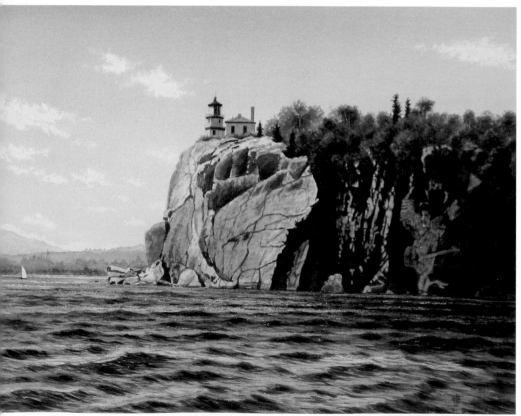

SPLIT ROCK LIGHT | WATERCOLOR, 20" × 27" (51CM × 69CM), PRIVATE COLLECTION

Every so often someone will come up to me and ask me when I'm going to retire. I look them in the eye and say, "And do what? Paint?" I love what I do and I've had a rich life doing it. Most artists do their art until they die, which is what I intend. Frank Lloyd Wright was working well into his nineties, as was Picasso.

You're never too old to learn how to paint. I haven't kept statistics, but thinking back, I'm sure that more than 50 percent of my students are retirees. These are people who always wanted to paint but circumstances had not allowed it. Now they're at a point in their lives, as you may be also, to give it a shot. I give all of them, you included, a lot of credit. I know that you'll find great joy in the process.

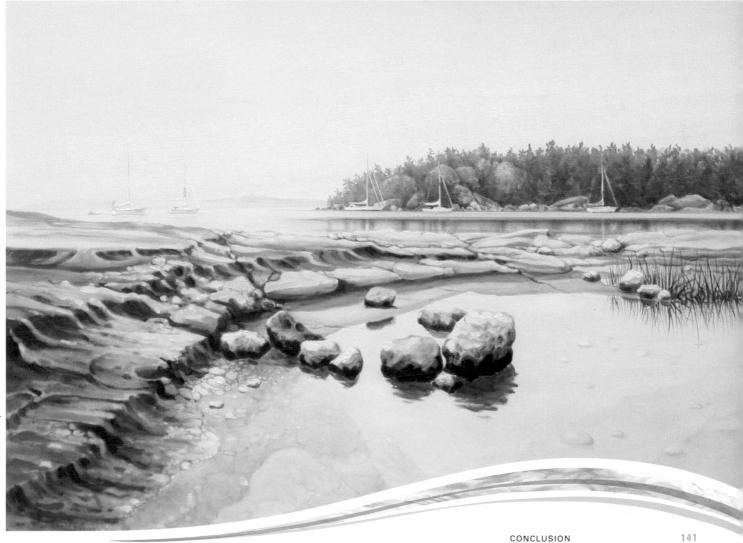

BENJAMIN ISLANDS | OIL, 24" × 30" (61CM × 76CM), PRIVATE COLLECTION

INDEX